D0392619

Giovanni Bellini

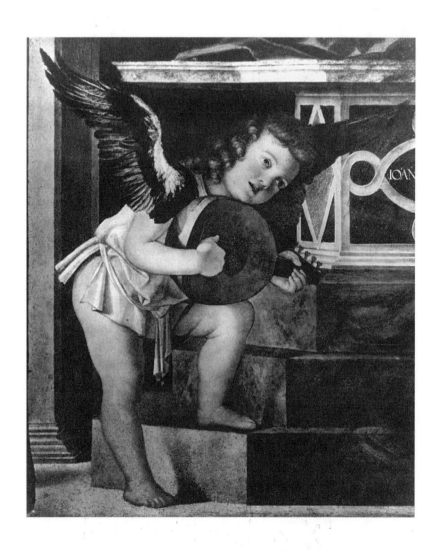

Madonna and Saints; Altarpiece, detail. Frari, Venice.

Giovanni Bellini

Roger Fry

Introduction by David Alan Brown

Afterword by Hilton Kramer

URSUS PRESS NEW YORK 1995

Giovanni Bellini by Roger Fry, number two of The Artists's Library,
was first published
AT THE SIGN OF THE UNICORN, London, 1899.

ISBN 1–883145–03–1

Designed by Ronald Gordon.

Contents

List of Illustrations

Introduction

*M*odern readers of Roger Fry's essay on Giovanni Bellini will appreciate the deftly sketched historical background he supplies for his subject. But they may be taken aback by what the author says about Bellini's first work. To prove that the *Crucifixion* in the Correr Museum in Venice was indeed by the artist, Fry cites the "disproportionate length and straightness of the forearm [and] the obtuse insertion of the thumb." Equally characteristic of Bellini, he finds, is the form of Christ's eyes with their "well marked sockets." Of course, Fry does not limit himself to such minor matters; he makes a better claim for the originality of the picture in relation to its sources. But the "thumb" and other morphological idiosyncrasies crop up in the text fairly often, and we need to take them into account to understand Fry's approach to the artist. The fact is that in this respect his book belongs very much to the period in which it was written. The turn of the century was the heyday of "scientific" connoisseurship, founded by Giovanni Morelli as a method of establishing the authorship of early Italian paintings and perfected by his most brilliant disciple Bernard Berenson. Making attributions has lately fallen into disfavor, but the practice was then widespread, and Fry's enthusiasm for it (he was trained as a scientist) would have been shared by his readers. As a connoisseur, Fry never betrays the kind of malice Morelli and his followers displayed toward their competitors, but he was guilty, as they were, of the sin of omission. Young Berenson, upon whom Fry modeled himself, was an iconoclast, frequently demoting pictures he later accepted (of the

eighteen Bellinis in the New Gallery exhibition of 1894, he endorsed only three). This accounts for Fry's otherwise puzzling downgrading of the *Feast of the Gods,* then in an English private collection, which Berenson had mistaken for the work of Basaiti (to whom Fry later gave the Frick *St. Francis*). Aside from this hypercriticism, though, Fry's goal was praiseworthy—to extract the quintessential Bellini from the mass of imitations, many of them signed, that passed for the master's work.

The attribution of major paintings to Giovanni (as opposed to the vast output of his shop) is no longer much of a problem, but another preoccupation of the connoisseur—the artist's chronology—is still with us, particularly so for Bellini whose style underwent the most extraordinary development of any fifteenth century Italian painter. As Fry saw it, the pathos of early devotional panels, like the Brera *Pietà,* gave way to the placid naturalism of the artist's mature productions. By limiting Bellini's *oeuvre* to a core of works placed in order so as to show his evolution, Fry aimed to sharply define his artistic character. Again, the model was Berenson whose pioneering monograph on Bellini's erratic pupil Lorenzo Lotto came out in 1895, four years before the publication of Fry's essay.

Fry thanks Berenson in the preface for his "generous encouragement and learned advice at the outset of this undertaking," the careful choice of words indicating that he, rather than his mentor, formed the view of Bellini taken in the book. In fact, Berenson had surprisingly little to say about the artist in his *Venetian Painters of the Renaissance* of 1894. And the team of Crowe and Cavalcaselle offered only banal visual analyses of Bellini's works in their *History of Painting in North Italy* of 1871. It was Ruskin, Fry's predecessor as the leading English art critic, who fashioned the pious image of the "last great religious painter" that readers would have brought to Fry's book. Fry sought to demolish Ruskin's Bellini and in doing so to make the painter accessible to the early twentieth century. His success may be judged from the

fact that Bellini's reputation did not decline with those of two other Victorian favorites, Fra Angelico and Francia.

But Fry's essay cannot be dismissed as a period piece, just as his absorption in the study of Italian painting was not merely a fashionable pursuit. From his own perspective as a painter, Fry drew attention to aspects of Bellini's creativity that were then undervalued but are now considered fundamental. He took a painter's interest in Giovanni's use of the Flemish technique of semi-transparent oil glazes, for example. And the portrait painter's concern with human psychology is reflected in his penetrating characterization of the saints portrayed in the *Coronation of the Virgin* in Pesaro. But it is Fry's sensitivity to Bellini as a landscape painter that provides the real revelation of the book. Making the by now standard comparison between Giovanni's *Agony in the Garden* and Mantegna's version of the same theme, both in the National Gallery, London, Fry associates Bellini's emergence from his brother-in-law's shadow with the Venetian's new and intense feeling for nature. A landscapist himself, Fry beautifully evokes the scene—the relation between the figures and their setting—in the Naples *Transfiguration* or the late San Giovanni Crisostomo altarpiece. "We look through the arch," he says about the latter, "upon the strangest, most romantic enthronement ever conceived—an old hermit, who has grown by long years of secluded contemplation into mysterious sympathy with the rocks and plants and trees of his mountain solitude, sits in a scarlet robe, silhouetted upon a golden sunset sky, across which faint purplish clouds are driven by the wind; and below him there appears a vast expanse of valley and mountain ridges. Bellini's intimate Wordsworthian feeling for the moods of wild nature finds here its remotest and sublimest expression."

Descriptions like this one admirably convey a sense of actually looking at Bellini's paintings in churches and galleries with Fry as a companion, sensitive to both their formal and expressive values and learned but never pedantic. It is no wonder that the

first edition of the book was immediately followed by two more, the second of which came out in America. Fry saw Bellini with an artist's eyes. And so did Giorgione and all the other forward-looking young painters who flocked to his studio in preference to that of his brother Gentile, the "official" painter of the Venetian Republic. Albrecht Dürer, visiting the city in 1506, reported that Giovanni, though very old, was "still the best in painting." Fry may have been exaggerating when he ranked Bellini, with Leonardo, as the greatest master of the fifteenth century. But he was surely right in the sense that Bellini, for the conviction and sheer artistry of his finest works, had no rival before Titian.

DAVID ALAN BROWN
National Gallery of Art

Preface

*I*n carrying out the present work I have received much kind-
ness and assistance from various sources. While accepting the
responsibility for any disputable conclusions here put forward, I
record with great pleasure my indebtedness to Mr. Bernhard
Berenson for his generous encouragement and learned advice at
the outset of the undertaking; to Prof. H. E. Wooldridge for sev-
eral valuable suggestions; to Dr. Ludwig for communicating to
me the result of his researches on the allegorical pictures; to
Signor Frizzoni for allowing me to reproduce the painting by
Bellini in his possession; and finally to Signor Anderson of Rome
and Signor Alinari of Florence for their generosity in permitting
the reproduction of copyright photographs.

R. E. FRY
Dorking, June 1899.

To H. F.

I. Venice in the Fifteenth Century

*T*he happy serenity of Bellini's art, its tenderness and human-
ity, spring in part from the good fortune of his life. His father,
Jacopo Bellini, was himself a great and acknowledged genius,
whose work proclaims him master of a delicately humorous
fancy, of a brain stored with quaint and unexpected conceits, and
above all, of a supreme sense of pure beauty; he was a man, too,
of rich experience, a traveller who had seen Brunelleschi at work
on the great dome at Florence, who had performed public
penance in that city to expiate an act of impulsive loyalty,[1] who
was intimate with the courtly circles of the Estes at Ferrara, and
was known to art patrons throughout North Italy. Giovanni
Bellini's brother, Gentile, was the most learned and the most seri-
ous artist of his time in Venice; and his brother-in-law was Man-
tegna. All these must be reckoned as singular advantages in the
circumstances of an artist's youth, and were likely to impose on
him either the highest excellence or total annihilation; no artis-
tic mediocrity would have been possible in a family circle such
as that!

But perhaps what counts for as much as anything in the for-
mation of the genial and well-balanced temperament, which his
pictures reveal, was the more general circumstance of his Venet-
ian birth—the fact that he lived most of his life in Venice, and that
he enjoyed, almost by right of inheritance from his father, the
confidence and admiration of the Venetian people and the
patronage of the Venetian senate. It is necessary, therefore, to
summarise briefly the conditions of Venetian life in the fifteenth

century, conditions of which Bellini's works are a typical out-come. For Venice was isolated among all the States of Italy: in political constitution, in religious ordinance, in dress, in customs and manners, in the greatest affairs as well as in the minutiae of daily life, the Venetians were unique and peculiar. A Venetian cit-izen was baptized, was betrothed, was wedded, was buried according to a code of usages which differed profoundly from those in vogue elsewhere. His consciousness of this isolation was only equalled by his pride in it; he was always Venetian before he was Italian. To us who enjoy a somewhat similar isolation, and are not displeased at arousing a similar envy[2] abroad, the Venet-ian is likely enough to appear justified; for Venice was the rich-est, most comfortable, best governed[3] and securest city-state in the world; the only State in Italy where faction fights and revo-lution were unknown, because there only one party existed, and that possessed supreme power; the only State where lawlessness was uncommon, because the governing classes had a tradition of public spirit and administrative science, which never had time to grow up in the disturbed political soil of other Italian States. Venice was to Italy what Sparta had been to Greece; her consti-tution was the envy and admiration of political theorists. As the Spartan when abroad commanded universal respect, so the Venetian senator was always the greatest[4] gentleman of whatever society he frequented; and the intense practical patriotism of the Venetians, as of the Spartans, left them no emotion to spare for the splendid dreams of wider national unity in which Florence and Athens indulged. But if we take Venice as the modern ana-logue of Sparta, for the rigid asceticism of manners enforced by the Law, we must substitute the gratification of the senses as a conscious State policy; and it is remarkable how little difference in the political, and how great a difference in the artistic result, the alteration makes. It is unnecessary to dwell in detail upon the extravagant expenditure of the Venetians on outward display, which was as surprising to contemporary foreigners as it is to us.

2

A few facts will suffice. A German writer of the fifteenth century, Felix Faber of Ulm, says that the Venetian ladies on great occasions adorned themselves with such splendour, that one would say that they were Trojan attendants of Helen, or Venus herself, rather than Christian ladies. And the great occasions which afforded an excuse for this finery were numerous. The Doge made no less than thirty-six processions annually to various churches of the city; and on fourteen of these occasions he was accompanied by the whole of the nobles, dressed in their state robes. Besides these, the Venetians made an excuse of every event of importance, such as the visit of a prince, a victory, or the conclusion of a treaty, for a pageant of extraordinary splendour. A Venetian child of noble family could not be baptized without the assistance of about a hundred and fifty godparents, to each of whom the father made a present; nor could a rich Venetian be buried without a cortège of about five hundred persons, and at a cost of three or four hundred ducats, equivalent to at least three times as many pounds of our money. But the colour and variety of Venetian life did not consist solely in her public functions; as the one means of communication with the East, as the market of all that was beautiful, sumptuous, or curious, in artificial products, where, moreover, in spite of Papal prohibition, thousands of Tartar and Ethiopian slaves were to be seen on sale; as the one place in Europe where there was some knowledge and much curiosity about the vague world beyond, Venice was the city of the widest actual (as opposed to ideal) horizon in Italy. It was the place of all others where the variety and complexity of human life would appeal to the artist through his senses and emotions, and where he would scarcely attempt to formulate any abstract or intellectual ideal.

For against the richness of sensational life in Venice we must set the comparative poverty of intellectual life. In Florence the Medici kept open house for humanists; but it was not so at Venice: there, both seedy Greek adventurers and men of solid

learning had chalked the doors of the senate as one where the learned beggar could gain nothing by applying. When, once in a way, a Greek scholar like Filelfo did find his way to Venice, enticed by the offer of a fabulous salary to be made by lecturing, he nearly died of starvation and plague, and soon drifted on, like the Greek books which passed through Venice unheeded, to Padua, Bologna, and, best of all, to Florence. Men of learning there were in Venice from time to time, nobles like Bernardo Giustiniani and Francesco Barbaro, whose early youth gave promise of that universality of genius which so often distinguished the men of the period; but the State claimed their absolute devotion from the time that they were of age to enter the senate; and music, poetry, and the classics had to be abandoned. Barbaro, it is true, kept up a correspondence with the humanists of Florence; and his talents won him a reputation throughout Italy; in Venice he was merely one of the servants of the State, of no account for anything he had written or learned, but only so far as he had performed loyal service. With a mistress whose rigours only provoked their more absolute devotion, the nobles could be at best but dilettanti in the humane studies; such men as Leo Battista Alberti and Leonardo da Vinci, men who approached ideal studies in the dominating spirit engendered by high birth, were impossible in Venice; and her great artists springing from the people lacked the exalted self-consciousness and wide intellectual outlook, communicated even to uneducated artists who frequented the Medicean coteries.

It was natural, therefore, that the enthusiasm for the new Classical culture, which led Alberti and Malatesta to discuss the establishment of paganism as an official religion, would find but little response among the Venetians. They were in a sense too genuinely pagan to care about the echo of a paganism of the remote past. For the tradition of Venice was unbroken; and in the attitude of her governors to religion she seemed a survival into modern times of a Greek city-state. The religious sentiments of her

4

citizens centred round the great relics of the body of S. Mark, the blood of the Redeemer, and the wood of the true cross, the first of which had at least as much political as spiritual importance. "S. Marco e gli altri dodici apostoli" was the Venetian's quaintly patriotic method of calculation. S. Mark, indeed, was as much the deity of Venice as Diana was of Ephesus; and on the strength of his divine tutelage the Doge lost no opportunity of declaring the independence of Venice from Papal jurisdiction.

Venice was, however, pre-eminently orthodox, it was "the most religious and well-governed city": but religion was culti-vated for its immediately beneficial effects, for the orderliness and respectability which the regular habits of religious observance were found to engender, as well as for the opportunities which it provided for symbolising the idea of the State, rather than for any metaphysical realities underlying it; and her citizens were never tempted by their religion into the extravagances of saintliness. Neither a S. Bernardino nor a Savonarola could have arisen near the Rialto.

A similar inaptitude for remote or speculative thought made the Venetians still less likely to favour the new devotionalism of platonic philosophers and neo-pagan enthusiasts. The attitude of Venice to Christianity, and to the humanistic culture which was elsewhere setting up rival claims to the devotion of mankind, was determined in both cases by the peculiarly positive temperament of her citizens, by their efficient common sense, their aversion to all that was strained or excessive.

1. Crowe and Cavalcaselle, *History of Painting in N. Italy,* vol. i.
2. "Si saiges et tant enclins d'accroistre leur seigneurie, que, si'l n'y est pourveu tost, que tous leurs voisins en maudiront l'heure." Philippe de Commines, Memoires, ed. Chanteleuze, Paris, 1881, livre vii. chap. xviii.
3. The Venetians were the inventors of "consols" and sanitary inspectors.
4. Benedetto Accolti.

II. Padua

*I*n both these respects, however, the neighbouring town of Padua, subject to Venice since 1405 and bound to it by ties of constant intercourse, formed a striking contrast. There, rhapsodical enthusiasm for the supposed remains of Livy, her greatest citizen, alternated with vehement repentance for the sins denounced by S. Bernardino. There, the immediate claims of life were less pressing; and the citizens could respond unreservedly to the demands, now of a Pagan, and now of a Christian appeal to their imaginations. Hence all those ideal studies, both of theology and the classics, which would have interrupted the weighty affairs of State and the practical business of Venice, were safely relegated to the neighbouring University town. The school of art which arose at Padua, and which influenced Venetian art very profoundly, shows signs of that less balanced, more intensive temperament of her citizens; and both their fervour and their classicism are reflected in the frescoes of the Eremitani. Paduan art, with its doctrinaire severity, its tendency to logical abstraction, was an important and by no means undesirable corrective to the more purely sensuous and unintellectual temperament, which was habitual to the artists of Venice.

For the Paduan school, accepting as it did with characteristic fervour and conviction the guidance of Classical art, and aiming at a limited and perfectly realisable ideal of formal design, discovered a self-conscious and coherent style at a time when the Venetian school proper was still plastic and tentative. Until about 1470, then, we find the tenderer and more sensuous feeling of the true

7

Venetian temperament overlaid with Paduan formalism. It was not till Giovanni Bellini had reached middle age and Alvise had replaced Bartolommeo as head of the Vivarini group that the exquisite and fanciful grace which had pervaded Jacopo Bellini's designs reasserted itself as the dominant note in Venetian painting.

III. Jacopo Bellini

In studying the formation of Giovanni Bellini's character as an artist, whether we consider those general habits of thought which decided his choice of subjects, or the technical equipment which dictated the manner of their execution, we must keep in mind two main determinant factors: the influence of his father, and the influence of the Paduan artists by whom he was surrounded in his youth. For although Jacopo's home was in Venice, he was employed largely on the mainland; and his decorative works in the Santo at Padua must have kept him and his sons for long periods of time in that town.

It is unnecessary here to recapitulate the often-told story of the origins of Venetian painting: of how the feeble traditions of indigenous artists, like Jacobello del Flore, were quickened into new life by the advent of Gentile da Fabriano and Pisanello to decorate the Ducal Palace in 1421. We may assume here the substantial truth of the usually accepted[1] account of Jacopo's training under the two great foreigners, and his continued service under one of them, Gentile da Fabriano, at Florence. For Jacopo shows himself in his sketches, which, owing to the almost total destruction of his paintings, are our chief authority, as an ardent follower of the new movement which these two artists were diffusing through North Italy. Pisanello was undoubtedly the master spirit of this propaganda; and he, more than anyone else, effected for art the change from the threadbare vestments of an ecclesiastical academicism to the modish garments of contemporary chivalry. The art which he and Gentile practised was frankly,

unscientifically naturalistic. More innocent of perspective than Giotto's, their composition is at times almost accidental; and it remained for the new school of naturalists, which arose at the beginning of the century in Florence, to exploit scientifically the new provinces of wild nature and contemporary life, first annexed by Pisanello. A similar work of systematising the greatly extended resources of quattrocentist art went on before the middle of the century at Padua; and there, as at Florence, the antique was appealed to as the guide in the work of classifying and formulating the infinity of nature. Jacopo Bellini's attitude, as shown in his sketches, is that of a man overcome with delight at the new powers of design which Pisanello's art had revealed. He draws every conceivable object, the banal as well as the sublime, and with equal joy in his sheer power of representation; and he brings his diverse objects together, not without some violence to their natural significance, into compositions which scarcely make more than a formal pretence to be religious. His worldliness, his love of wild animals and the wild aspects of nature, relate his art to that of Pisanello. Moreover, the individual forms of his landscape, the shapes of hills and trees, derive from Pisanello's and Gentile's. But in his synthesis of the picture as a whole, he shows signs of that more scientific construction, according to the laws of linear perspective, which Uccello[2] was working out in Florence. His love of perspective is indeed as keen, and his application of it as extravagant, as it was with the Florentines; but his knowledge is more empirical, and he left much to be accomplished by the more methodical genius of his son Gentile. It was at Ferrara, under the stimulating patronage of the Estes, that Pisanello's emancipation of art from ecclesiastical tradition was most clearly proclaimed; and it was not long before the appeal to Classical art, in directing the new growth, manifested itself there. Pisanello himself, towards the end of his life, recognised in Classical sculpture an anticipation of his own expression of the free delight in nature. Jacopo's strong feeling for Classical art is there-

fore to be accounted for by his connections with Romagna and the Marches. From Pesaro, to the south, he took his wife Anna; and Pesaro was close to Rimini, an even more advanced stronghold of neo-pagan culture than Ferrara, where at the Ducal court he was considered a second Phidias.[3] Indeed Jacopo was entirely in sympathy with the mundane and pagan art of the small courts of Ferrara and Rimini; and his enthusiasm for Classical sculpture is proved by the constant introduction into his sketches of figures betraying their derivation from a late Greek statue; while no more sympathetic interpretation of the lyrical spirit of Greek art had been seen than his drawing of a revel of centaurs and satyrs. We shall see in studying Giovanni Bellini's works, that this early outburst of the paganism of the full Renaissance was premature, and affected only the aristocratic circles of the small courts. It was fifty years before Giovanni's pupils expressed once again the mood of Jacopo's revel. Before leaving Jacopo's art, we must notice how unscientific his structure remains to the end; how, even when he is copying Greek marbles, he draws with the unreflecting and illogical grace of the mediaeval draughtsman. There is no reduction of the shapes of nature to a well understood formula, no emphasis on those parts of the figure which scientific analysis shows to be cardinal.

1. For the story see Crowe and Cavalcaselle, *History of Painting in N. Italy*, vol. i.; for doubts as to its veracity see J. P. Richter, *Lectures on the National Gallery*; and for a defence Gronau, in *La Chronique des Arts et de la Curiosité*, vol. xxvii.

2. He may have come across Uccello at Florence, or Venice, or Padua; Uccello was in Venetia from 1425 to 1432. See J. P. Richter, *Notes on Vasari*, p. 44.

3. For his relations with the Estes, and his competition at Ferrara with Pisanello, the reader may consult a "Note on Jacopo" in the *Dome*, Feb. 1899.

IV. The Squarcioneschi

\mathcal{A} ll this necessary work of reduction to a canon was, however, the especial delight of Jacopo's rival at Padua, Squarcione, and of his famous art school. Squarcione's pupils, though they understood the spirit of Classical art far less than Jacopo, were more industrious in studying its forms, and in applying the general laws derived thence to every part of visible nature. Squarcione himself, the father of the school, was a powerful artistic influence, even if, as Vasari says, "he was not the best of painters."[1] He was a designer of embroideries, and in his youth travelled in Greece, whence he was supposed to have brought back a collection of antiques. The art which derived from his influence (according to the legend he had a hundred and thirty-seven pupils) was marked by a strong inclination to rigidly decorative schemes, as would be likely where painting was approached from the side of conventional design. In these paintings the Gothic forms prevalent till then were replaced by careful and often pedantic adaptations from Roman bas-reliefs, and his more immediate followers, like Schiavone, without any appreciation of the essential freedom of Classical art, nevertheless carefully stamp the Virgin's throne in their pictures with the letters S.P.Q.R. It was only the greater spirits of the school, like Pizzolo and Mantegna, who, coming under the vivifying influence of Donatello, arrived at a more real conception of Classical art than that which regarded it as affording a new fashion for the embroidering of an altarpiece.

But what is most singular in the Paduan scholars is the attitude

13

to nature which their predilection for decorative schemes engendered. They sought always to distil from nature a statement of form, as rigidly logical in the interrelation of its parts as one of their master's embroidery patterns. Starting with more or less correct but vague notions of the shapes of natural objects, they began to reconstruct them according to purely internal ideas of fitness. It was this *a priori* way of approaching nature that led the Paduan artists to build their hills in terraces which run round them in nearly parallel courses; to joint their rocks with the regularity of masonry; to mark the articulations of the figure with forced precision, and to construct their drapery on a principle of intertressed folds, designed to display the underlying form by following its contour in every direction. Another important characteristic of Paduan art was the peculiar tempera technique, which their desire for decorative completeness and firmness of expression led them to elaborate, and which in turn dictated their outlook upon nature. Over a flat general tone circumscribed by firm outlines, which remained visible in the finished picture, they modelled with hatched strokes, whitish on one side of the figure, dark on the other, and finally, under pretext of a reflected light, they introduced a faint light edge within the outline on the dark side, in order to mark with yet one more contour their elaborately planned design. Although such a technique was incapable of rendering the more subtle beauties of natural objects, the softness of flesh or the bloom of a velvet, it was admirably suited to that patient hammering out of a definitive and unalterable form which the Paduans accomplished; and, in the hands of its best masters, the picture could by it be brought to an unyielding and lacquer-like firmness of surface, not without its charm when regarded rather as a beautiful substance itself than as symbolical of beautiful realities.[2]

14

1. His work at Berlin now accepted as genuine shows that he was capable of originating the system of design which is common to his followers.

2. The characteristics here described are found, it is true, among artists who did not belong to the Paduan school proper: Bartolommeo Vivarini, Crivelli, and Giovanni Bellini share them at some period of their careers. But we are forced to regard Padua rather than Venice itself as the focus of this system of design, and this for various reasons:—it was at Padua that it was most constantly practised and most consistently followed: its essentials appeared there already in the work of Squarcione, while his Venetian contemporaries, Jacopo Bellini and Antonio da Murano, belong still to the older more mediaeval school of technique: of those Venetians who adopted it, only Crivelli, who lived in isolated seclusion from subsequent artistic influences, persisted in it to the end; the two Bellini quickly dispensed with it and adopted a more truly Venetian manner: Bartolommeo Vivarini's gradual and constantly increasing apprehension of its principles is scarcely consistent with the supposition that it arose in Venice: finally, the geographical distribution of the stereotyped motives belonging to the style indicate Padua as its point of origin: Ferrarese art was inspired directly thence, and at Modena, Faenza, even as far as Milan, we have evidences of distinctively Paduan motives; taking this in conjunction with Squarcione's fame as a teacher, and the reputed number of his pupils, we can hardly doubt that in the years between 1440 and 1460 the Paduan school, with its thoroughly elaborated and compact system of design, was the strongest artistic influence in North Italy. It was, however, quite possible for artists like Bartolommeo Vivarini and Negroponte to pick up the main ideas of Paduan design in Venice itself, where Squarcione was employed on the decorations of the *scuola* of S. Marco.

V. Bellini's Early Life

\mathcal{T}he most important documents bearing on Bellini's early life are those discovered by Signor Paoletti;[1] but even by their aid we cannot fix with certainty the date of his birth. In 1429 Anna, Jacopo Bellini's wife, being with child, made a will, in which she left all her property to the expected son or daughter, if he or she should reach majority. The child, here provided for, was probably Gentile; for it was evidently her firstborn, and Gentile appears in after years as the head of the family. If then, as is usually supposed, Giovanni was a slightly younger son of the same Anna, we should have to fix the date of his birth early in the thirties. But possibly Giovanni was not Anna's son at all; for in a later will, made in 1471, she left everything to "Gentile et Nicolao filiis meis et dicti quondam magistri Jacobi equaliter" (besides which a brown cloak "a meo dosso" was to go to Nicolao). Giovanni is left out altogether. It is therefore at least a possible conjecture that Giovanni was an illegitimate son of Jacopo Bellini, and may have been after all, as Vasari hints, the elder of the two.

The various documents of the next two decades are important, as showing that the Bellini family regarded Venice as their home, and not Padua, as has been hitherto supposed; that Jacopo was already in 1437 a member of the *scuola* of S. Giovanni Evangelista, and probably recognised as a leading artist in Venice. This, though it in no way lessens the probability of their intimacy with Paduan artists, proved alike by Mantegna's marriage and the evidence of pictures, shows that the two sons grew up as the recognised heirs to a leading position in the artistic circles of Venice.

We gather from the documents referred to that Giovanni and Gentile lived with their father; at first close to the Piazza of S. Marco, and afterwards in the parish of S. Lio. Their chief employment was in assisting Jacopo in the great decorative works,[2] which he executed for the *scuole*[3] or mutual aid societies of the town, in the processional banners[4] and sepulchral monuments,[5] which together formed the chief field[6] of his activities. Beside these works in Venice, the two sons were Jacopo's assistants in the decoration of the Gattamelata Chapel at Padua, a work which went on till the year 1459. The relative position of father and sons is suggested by a document of 1457 in which we find that "for three figures done on cloth put in the Grand Hall of the Patriarch" Jacopo received twenty-one ducats, of which only two were for his son. Somewhere about the year 1460[7] we may assume that the sons, who had already executed many small works independently, set up on their own account. It must have been either during the visits of the Bellini to Padua, or on those occasions when Squarcione, probably accompanied by members of his school, came to Venice, that the intimacy with Squarcione's adopted son Mantegna began; an intimacy which led to his marriage in 1453 with Nicholoxa (Niccolosia), Jacopo's daughter.

1. *Raccolta di documenti inediti*. Padova, 1894.

2. Called "histories" in the contracts. Even at this date it was the peculiar Venetian practice to do wall decorations on canvas.

3. For an account of these bodies which filled so important a part in the life of the city, see Sansovino's *Venezia Descritta*.

4. Such as that done in 1452 for the scuola della Carità. The contract expressly states that Jacopo must do the faces himself; a sign of how much he already relied on his assistants.

5. Such as that done in 1456 for the tomb of Lorenzo Giustiniani.

6. It is noteworthy that the patrons of the Bellini are mostly secular bodies like the scuole. The making of altarpieces was a distinct business in the hands of the Vivarini of Murano.

7. We have no documentary evidence of their independence till 1466, when Gentile undertook a work in the scuola of S. Marco. The organ shutters of S. Mark's, however, must have been executed some time before this.

18

VI. Bellini's Works,
First Period Ending 1460

\mathcal{E}nough has now been said both of Bellini's antecedents and of the few ascertainable facts of his early life to enable us to approach the study of his works with some power of discriminating what in them is the result of external influences and what is the peculiar product of his artistic temperament. The works will be arranged here so far as possible in chronological order; although in this matter, on account of the scarcity of fixed dates, no two students of his work will be likely to agree entirely.[1] Bellini's early works are admirably illustrated by three examples in the Correr Museum at Venice, of which the earliest is the *Crucifixion*. This picture, although not universally accepted, has the following characteristics of his early work: the disproportionate length and straightness of the forearm, the obtuse insertion of the thumb which gives to the large metacarpus a regular pentagonal form. The face of the Christ, though meaner in expression than is usual with Bellini, is characteristic in the drawing of the eyes, the well-marked sockets and the rounded angles of the mouth. The landscape, with its roads winding in sweeping curves, is constant with him at this period, and the drawing of the rocks just behind the cross is almost identical with a passage in the *Transfiguration* of the Correr, which is accepted as his. A small point in favour of this picture is the Greek lettering always affected by Bellini. Assuming then that it is by Bellini, we are struck by the evidences that he has already thrown himself with fervour into the new movement towards a more rigorous definition of form than satisfied his father. Comparing this figure of Christ with

Jacopo's crucified Christ at Verona, we notice far more constant study of the model and more searching drawing: indeed, as is natural at this stage of his development, Giovanni is somewhat a prey to the accidents of nature; he has cast loose from his father's formula of easy flowing lines, and has not as yet discovered an alternative scheme. Thus the unpleasant angular prominence of the radius at the elbow, which accomplished artists like Donatello knew how to modify, is here too faithfully copied; and in general there are signs of the over-statement of facts which his study of the figure led him to recognise as important, such as the exaggerated curvature of the shin bones. Perhaps we can still trace something of Jacopo's grace in the swing of the Virgin's pose and the long unbroken draperies, but on the whole Giovanni is going with the current of the young Paduan artists—the motive of the skull-like rock, jointed with unnatural regularity, the soldiers with their long thin legs and high shoulders, the landscape with its forms defined by innumerable nearly parallel contours; all these, though at present expressed with less rigour than was usual at Padua, are distinctive motives of that school.

In the *Transfiguration* (also in the Correr) we have the next step in which all these Paduan characteristics are intensified; they are now no longer the vague elements common to the school, but remind us distinctly of one member, Mantegna himself. All reminiscence of Jacopo's flowing line has here disappeared; grace is sacrificed entirely in the research for perfectly defined form: it is the work of a student pushing a new theory of design to its furthest limits, with something of the *outrecuidance* of youth. The draperies are wrapped tightly round the limbs, and the folds, which rise like wales on them, are regarded as separate objects crossing under and over each other and following the articulations of the body with suspicious regularity. The position of every line is here arrived at more by thought than by vision. The *a priori* method of design could scarcely go further.

Nor have we in this work any trace of that suavity of manner,

that ease of gesture, which we are accustomed to associate with Giovanni's name. The movements of the figures are harsh and tense; the S. John bends back his foot and cramps his toes with a muscular effort, suggestive of an uneasiness and distress which more or less pervade the whole picture. The mood is one of strained anxiety and terrible pathos. In feeling as well as in technique it is almost nearer to Mantegna's[2] grandiose manner than to Bellini's; and yet it is evidently by the latter, for, not to mention the peculiar form of hands and the purely Bellinesque head of the S. John, there is an intimate tenderness in the expression of Christ's pathetic appeal (reinforced by the quotation from Job on the cartellino) which only Bellini, the supreme master of pathos, could have accomplished. Bellini never again pressed the principles of exaggerated structural definition so far as he does here; but there remain a number of works in which these doctrinaire notions still prevail: nor was it for many years yet that he discovered his own more sensuous and more truly Venetian manner. It is impossible to be positive about the exact order of these early works, but we may take next the *Dead Christ Supported by two Putti* in the same gallery, bearing the forged monogram of Albert Dürer. The authenticity of this picture is disputed; but a comparison of the head of the Christ here with the head of the S. John in the later *Pietà* of the Brera, or the head in *The Blood of the Redeemer* of the National Gallery, ought to leave no doubt that the Christ at all events is Bellini's creation; the hands too are almost equivalent to signatures, showing as they do the peculiar oblique insertion of the thumb, which, together with their great size, gives already that suggestion of a warm human grasp so characteristic of the master's hands.

The landscape, although there is a walled city with Classical buildings more or less in Mantegna's style (compare the *Agony in the Garden* [National Gallery] and also the Jerusalem in the Ducal Palace *Pietà*), has Bellini's winding roads, and most important of all for the mood given thereby, his open and distant horizon line.

The putti are, it is true, strangely awkward in their movements, but Bellini, whose study of the full-grown figure was already far advanced, might nevertheless have adopted almost unchanged, as Crivelli did in his early Madonna at Verona, that curious type of putto invented by Squarcione, and which occurs throughout his pupils' frescoes in the Eremitani. But certainly, even if we should be compelled to admit in part the hand of an assistant, it would be strange to condemn a work so profoundly expressive already of that passionate sympathy which pervades Bellini's early religious works.[3]

The treatment in this picture, of the pietà with two putti, is very near to the composition of a bas-relief in Padua by the greatest artist that Giovanni Bellini came in contact with. Between 1440 and 1450, the years of Bellini's early apprenticeship, Donatello was in Padua, engaged on the great statue of Gattamelata and his bronzes in the Santo, and we can hardly doubt that Donatello's work was the original which inspired this form of the pietà. None the less, when we consider Donatello's unique position as the first master in whose work the whole significance of the Italian Renaissance found expression, and the overwhelming influence which we should naturally expect such a genius as his to exert on a school struggling to free itself from mediaeval superficiality, it is a little disappointing not to be able to point to more definite traces of his influence on the artists working at Padua; for though Donatello's strongly marked peculiarities of form, both in the figure and in drapery, were slavishly copied by sculptors like Bellano, the painters show but the vaguest reminiscences of them.[4] None the less, we cannot doubt the great importance of Donatello's presence in Padua, or the depth of his influence in a more general sense: Paduan art would never have approached so nearly to the uncompromising intellectuality of the Florentines without the stimulus of Donatello's example.[5]

Closely related to this pietà is the *Madonna and Child* belonging to Mr. Davis of Newport, U.S.A., and exhibited at the New

Gallery in 1895. The execution shows the same hard, thick impasto as the Correr picture, and the articulations of the sleeping child are like, though better than, those of the putti in the pietà. The landscape has the same winding road and a similar use of Classical architecture as a picturesque motive. It is curious that this, the earliest of Bellini's numerous Madonnas, is the only one in which the Virgin's hands are folded in prayer before the sleeping child—a composition which was constant with the Vivarini.

The Blood of the Redeemer (National Gallery). The head of Christ is very close to that in the last picture, while the exaggerated length and straightness of the forearms, and the shape of the hands, recall the still earlier *Crucifixion*. The peculiar drawing of the upturned sole of the angel's foot occurs in the *Transfiguration* and the later *Agony in the Garden*.

The subject of this picture is a rare one in Italian art. Matteo da Cividale treated it more than once in sculpture, and a very similar pose to Bellini's occurs in a Florentine woodcut of 1493;[6] but one of the earliest, if not the earliest of all, is that by Crivelli in the Poldi Pezzoli Collection at Milan, a picture which has many points of affinity with this. The pose of Christ in both pictures is based on the same motive, with differences characteristic of the two artists. In Crivelli's the weight is thrown on the left leg, the right arm embraces the cross, and the right hand stretches round it to press the blood from the same side, whereby the artist obtains just that complicated pose, with sharply reflexed extremities, which his feeling for affected elegance demanded. Bellini's pose, in spite of the great similarity, has that easy breadth of movement which expresses his larger, more genial nature. The round tower in the background, of which this is a unique example in Bellini's work, reminds us of more than one of Crivelli's early pictures; and as Crivelli was more directly inspired by Squarcione than any other Venetian artist, it is at least not unlikely that he may have been thrown with the Bellini at Padua, and that these two pictures were the outcome of their mutual intercourse.[7]

The technique of Bellini's picture is remarkable; already, in spite of the archaism of form, he shows a feeling for atmospheric tonality: the ruin to the right and the two figures near it are, as painters say, in their place; that is to say the treatment as regards tone relations is such as the linear perspective would lead us to expect. Still more surprising is the way in which the eye is led down the valley to free spaces of luminous air, of sunlit sea and hill.[8] This picture also marks a change to a thinner and more liquid impasto, than had obtained hitherto.

Madonna and Child (Collection of Signor Frizzoni, Milan). Of the same period as the last, and showing great likeness in the treatment of the drapery, this is technically one of the most perfect of Bellini's early works; the design of the drapery is more consistently carried out and more exquisitely finished than usual; and the whole surface is wrought to that beautiful, transparent vitreous quality, which was the objective of the tempera technique already described. (A similar though inferior example of this technique may be seen in the Madonna by Bartolommeo Vivarini in the National Gallery.)

The hands in Signor Frizzoni's Madonna are unique in Bellini's work: the slight contraction at each articulation, as though the connective tissue were tied down by a circular tendon, is very peculiar, and, although the fingers are too long for him, the drawing reminds us forcibly of Mantegna. The arrangement of the hair, too, is one constantly adopted by that artist. Taking this with the fact that both the Madonna and the Child have more the appearance of portraits than is usual, Mr. Berenson has formed the ingenious and pleasing conjecture that we have here a portrait of Niccolosia Bellini, done at some time after her marriage with Mantegna, perhaps about 1455 when their first child would have been of the age represented here, a date which the technical treatment would justify.

Of somewhat later date than the two last pictures is the *Agony in the Garden* (National Gallery). The composition of the land-

scape, with the little stream making a loop to one side of the picture, crossed by a small bridge and with a bare tree on its bank, must be referred to Jacopo Bellini. The mound-like shape of the Mount of Olives is reminiscent of him; and the wattled fence filling up a corner of the foreground is a frequent device in his sketches. It is evident that, however much Giovanni and his compeers diverged from Jacopo's conception of the detailed forms of figure and drapery, they were not blind to the idyllic charm of his compositions as a whole. For we have evidence from the very similar treatment of the same subject, which hangs in the adjoining room, that Mantegna also was at this time indebted to his father-in-law's fertile invention. In the "Agony" alluded to, Mantegna relaxes into a more fanciful and charming view of nature than was habitual to him, though even here he closes in his horizon with an impenetrable wall of rocky hills; the rabbits at play, the pelicans in the stream, the eagle on the bough, are all motives that one may trace back to Jacopo, and their spirit at least to Pisanello himself, whose S. Hubert hangs significantly near. In estimating Jacopo's[9] influence it must be remembered how rare at this period were pictures in which the landscape played so prominent a part, and in which the sympathy of mood between figures and landscape was an object of conscious research. Giovanni Bellini was absorbed in middle life by more conventional compositions; but it is scarcely too much to say that the peculiar freedom and the intense lyrical charm of early cinquecento art in Venice can be traced back through a series of occasional pieces by Giovanni to the rich and unrestricted fancy of Jacopo Bellini's compositions.

But to return to the picture, or rather to the two pictures, for their affinity is so great as to force on us the idea of collusion between the two artists. Indeed the figure of Christ is in each little more than an inversion of the other; but while Bellini employs a convention of drapery with hard triangular folds tucked between the legs, which is almost identical with that adopted

some time before by Mantegna in the fresco of the baptism of S. James, Mantegna himself has aimed at an appearance of greater verisimilitude; the art with which the draperies reveal the form is more artfully concealed. Bellini, in fact, shows in his version of the subject how little the Paduan mannerisms were really congenial to him, for he does not carry their system of linear design consistently through the whole picture. The broad unbroken spaces of the hill on which Christ kneels, and of the distant valley, and the more flowing drapery of the S. Peter, all break with the linear convention which he still adopts in the figure of Christ, and to some extent in the hill to the right. Mantegna, on the other hand, leaves nothing undetermined; every part of the rocks in the foreground and of the hills beyond is ringed with innumerable contours, illustrative of its form. Nothing could show more clearly that, whether Bellini came under the influence at Padua of a formula already elaborated, or, as is probable, worked it out step by step with Mantegna, the path that they had traversed together up to this point lay in the direct line of Mantegna's lifelong development; whereas Bellini was compelled to turn off at an angle in order to find the proper expression of what was most personal to him.[10]

And these two pictures belong to the last stage of their common journey. For once we can fix on a date (1459) with some show of probability; for Mantegna's was executed for Giacomo Marcello, Podestà of Padua up till 1459.[11] It was a critical period in the lives of both artists. In that year Squarcione and Jacopo and their respective followers brought to an end their labours, the one in the Eremitani, the other in the Santo. In that year or the next, Mantegna left Padua to serve the Gonzagas at Mantua, and the Bellini began to confine themselves more exclusively to Venice itself. The long intercourse between the greatest of the Squarcionesques and the Bellini, with all the friendly rivalry, the exchange of ideas on the principles of art, and of motives for compositions, which such an intercourse among students implies, was

over. With the year 1460 the student period of both artists may be regarded as closed.

It is no small good fortune, therefore, to have hanging within a few feet of one another two pictures in which each artist put himself into friendly competition with the other for the last time. Although Mantegna was probably the younger of the two, his genius was the more precocious; he had already arrived at complete self-knowledge, already found a style that was moulded to his temperament. His work has nothing tentative or experimental about it; it is the work of a man assured of his own powers and the direction that he is to follow to the end. But Bellini's was a subtler and a wider nature; one that would arrive late, if at all, at this mature perfection. Mantegna seizes only the sublimity of the idea of the Agony. Bellini's penetrating sympathy renders its infinite pathos. In Mantegna's landscape, miraculous definition of form is more evident than any dominant mood; but Bellini shows already that perception of the emotional value of passing effects of atmosphere, which is often supposed to be a peculiarity of the art of this century. Bellini has in this sunrise observed with perfect appreciation the effect of the dull green of the wooded valley against the apricot of the Eastern sky; but he has broken with literal accuracy by introducing on the neighbouring hill a beautiful and, in itself, perfectly true effect of pale rose buildings against a deep blue-grey sky; an effect which could only occur at the opposite pole of the horizon. Bellini is certainly less accomplished than Mantegna; and, although in the S. John the beautiful relaxation of sleep is exactly rendered, the poses of the other two disciples are somewhat hesitating and unconvincing, and their relation with the ground is scarcely realised. But in all that concerns the imaginative conception of the subject, in the harmonising of all the accessories, to produce a single profound impression on the emotions, above all, in the large and reposeful spaciousness of the composition, Bellini is, surely, the more to be admired.

Before passing to those works in which Bellini develops his purely Venetian manner, it will be well to look back on those early works whose technical problems have so far occupied our attention. The mere titles of the pictures are instructive; the *Crucifixion*, the *Transfiguration*, the *Pietà*, the *Agony in the Garden*, all are religious subjects; but more than that, subjects which involve the profoundest sentiments of Christianity. Now these subjects are treated by Bellini with an insight of sympathy so intense as to make one suppose him to have chosen them deliberately as an expression of feelings prevalent with him at this period of his life. It is no doubt rash thus to argue from the artistic temperament to the temperament of real life; the history of Italian art is not without its warnings of the danger. But in the case of Bellini's early works the feelings of pity and love are expressed with such frequency and such intimate intensity, as to make any other construction of his character impossible. The outward change, at all events, from the mundane art of Jacopo's sketches, which often treated religious subjects with surprising levity, is sufficiently striking. The reaction of Giovanni's generation was not only towards a new technique, it was a reaction of feeling as well; a revulsion from that premature paganism which had sprung up in the courts of Rimini and Ferrara. Though such a reaction was natural and to be expected in any case, it may at least have received greater impetus from the revivalist propaganda of S. Bernardino. In 1443, when Giovanni would be at an impressionable age, S. Bernardino preached the Lenten course at Padua. It was the climax of a lifetime spent in itinerant preaching. He had never before had such an amazing success; and his sermons, preached in the open air, were attended not only by the whole of the populace, but by the magistrates representing the sovereign State of Venice, the professors, lecturers, and students of the University. S. Bernardino naturally found much to condemn among the Paduans, who had so lately been attending with religious honours the bones of a pagan historian; but his chief diatribes

were directed against vanity, gambling, and the humane treatment of Jews. Except for the attendance of the cultured classes, these revivalist meetings seem to have resembled those of our own day, and women cured of possession by devils publicly testified to the efficacy of the saint's badge inscribed with the sacred monogram, his usual emblem in Venetian art. A proof of the enthusiasm which S. Bernardino aroused in Padua is furnished by the monastery of Sta. Chiara, the dedication of which was delayed till S. Bernardino's prompt canonisation enabled it to be put under his protection. In the same year, 1443, S. Bernardino went on to Venice, where he counted among his friends the Doge Foscari, the Blessed Lorenzo Giustiniani, the first patriarch of Venice, and most of the leading senators and distinguished men of the day. This visit of the great saint to Venetia, with the contagious fervour for Christian ideals which it provoked, may well have been a contributory cause of the more religious attitude to life expressed by Giovanni's generation. We shall trace later on the gradual weakening of those emotions to which his early works give such intense expression.

1. The author proposes to mention in this survey all those works of which the genuineness appears to him to be fairly ascertained. It is impossible here to give reasons for the rejection of all the works which have from time to time borne Bellini's name.

2. As being Mantegnesque we may note, beside the dogmatic statement of form in the draperies, the tree with branches coming out at right angles, with sparse, carefully planned foliage; the high, square shoulders of the figures and their disposition high up above the line of sight.

3. In the Poldi Pezzoli there is a pietà very similar to this one by an imitator of Bellini.

4. Only in Mantegna's earliest fresco of the Eremitani, "S. James casting out devils," do the forms of drapery and movements of figures approach Donatello's.

5. The Paduan and Venetian painters were not in a position to profit fully by the example of one who had already attained that free treatment of the figure which painters

acquired only towards the beginning of the cinquecento. Neither Mantegna nor Bellini had yet fully elaborated that archaic precision of form, from the complete mastery of which the free manner alone could proceed.

6. V. Kristeller, *Old Florentine Woodcuts*, and Dr. Richter, *Lectures on National Gallery*.

7. The S. Jerome in Crivelli's earliest work at Frankfort resembles the S. Jerome of Gentile's organ shutters in the curious drawing of the arms.

8. The bas-reliefs behind the figure of Christ are among the rare examples of Bellini's study of Classical sculpture; they are clearly intended as pagan prototypes of the idea of sacrifice.

9. For a totally different view see Dr. Richter's Lectures.

10. The view put forward here, by which Mantegna's is regarded as the dominant influence, is quite consistent with the possibility suggested by Dr. Richter (*loc. cit.*) that a sketch by Bellini gave Mantegna a first idea for the S. Zeno altarpiece. In a case like this it would be absurd to regard "influence" as the stamp left on a plastic substance by a rigid body; it is rather the mutual alteration of two bodies in process of formation.

11. Richter, *loc. cit.*

VII. Bellini's Works,
1460-1490

*A*mong the first works done after 1460 we must place the *Pietà* in the Brera, which in its low horizon light barred by long lines of cloud, its stream patterned by a diaper of wavelets, its winding road leading up to the houses which crown the hill, is closely related to the *Agony in the Garden*. But the points of contrast are more significant than the points of likeness. For here at last Bellini has shaken off the uncongenial intricacy of Paduan design; he has begun to find his own personal scheme, in which form is defined rather by the opposition of broad, scarcely modelled planes, than by multiplicity of contours. The drapery is no longer cut up into intertwining folds; it falls, still somewhat stiffly, no doubt, in large, uninterrupted masses. Bellini's feeling for these unmodelled surfaces is pushed to its extreme in the treatment of the nude; but the curious rectilinear collar bone and flat pectorals are not the result of ignorance of the figure; for already in his earliest known work he was more literally accurate; he is only emphasising his own newly found personal formula, which demands this summary simplification of the planes of the figure. In this particular case, such a treatment is dictated partly by the system of long horizontal lines, which pervades the whole composition.

Bellini having found at last a technical rendering of form more suited to his temperament, expresses himself with unrivalled power. Other pietàs rise to one's mind in which the extravagance of grief is more acutely rendered; others again, such as Giotto's deposition at Padua, where the whole cosmos seems rent with

unutterable anguish; but none in which the tenderness and intimacy of grief are so supremely rendered. The sorrow which Bellini has here conceived is divine only in its excess of humanity.

The subject in this form is derived by Giovanni from Jacopo; but the changes introduced by the son are significant of his greater depth of feeling. Thus in Jacopo's sketches, both arms of the Christ hang flaccidly down on to the tomb; here the Virgin presses one of Christ's hands to His side with a movement of tender solicitude: in Jacopo's compositions the head of Christ hangs forward with the indifference of death; here, with a movement which, but for Giovanni's tenderness, would be terrible in its irony, it is turned to the Virgin as in response to her appeal.[1]

An even more complete mastery of Bellini's newly acquired treatment is shown in the *Madonna and Child* of the same gallery. Here again the planes both of hands and face are defined by almost rectangular edges, while within each plane only the most delicate alterations of tone are permitted. Although the form is as precise in its main outlines as before, and although there remains a flavour of archaism, the suavity and grace which were such essential elements in Bellini's nature are here fully realised for the first time.

This decade marks a climax in Bellini's life. At last truly himself, free from all outside influence, he expresses with an intensity which never infringes on the claims of pure beauty, the profoundest sentiments of Christianity, pity, and love. The intensity of feeling gradually declines from this time onward; and his sense of what is purely gracious and delightful in life increases. But at this period Bellini's works are confined to two subjects—the Virgin and Child, and the Pietà. Besides the version of the latter subject at Milan, there are three others belonging to this period: the earliest belongs to Dr. Ludwig Mond; the next is in the Communal Gallery at Rimini; and the third is at Berlin. The Rimini picture is reproduced here, and is of great interest as showing the scholarly way in which Bellini was studying the figure at this time. He may well have felt that the scheme of flat rectangular planes,

as applied in the Brera *Pietà,* was too summary; that it was necessary, without losing that large simplicity, to reproduce something more of the beautiful sinuosity of the human body. Certainly in the Rimini *Pietà* he has done this, making an arabesque of supple childish limbs against the frankly conventional lacquered black of his background, by which he produces an effect as curiously reminiscent of Greek vase-painting as the head of the Christ is of Greek bronze-work. If, as Vasari says, it was painted in Rimini, and for Sigismondo Malatesta, this may be no mere accident.[2] This picture and the next mark the apogée of Bellini's feeling for structural design. He comes here close to the Florentines in perfect rendering of the rhythmical poses of athletic forms. In the later Berlin work it is the beautiful flaccidity of the dead figure that absorbs his interest. The pathos of the heads is indeed enforced by the scholarly research displayed in the figure, where plane succeeds plane, deriving in simple and inevitable sequence from the point of support in the left shoulder.

We cannot do more than allude here to the *Virgin and Child* of the Madonna del Orto at Venice, and of the Lochis Collection at Bergamo, which belong to this period; and we must pass on to the works of the next decade. The fact that we are obliged to give so few of Bellini's remaining works to this period, is partly to be accounted for by supposing that he was at this time engaged on large decorative works for the *scuole,* a business in which Gentile had for long been employed. The contracts of the Scuola di San Marco show that Bellini's first employment there was in 1470. In 1466, Gentile had begun there "the history of how Pharaoh came out of the city, and how he was submerged, and (in a second picture) how the other people of Moses was in the desert." In 1467, Bartolommeo Vivarini and Andrea da Murano were engaged to do "linstoria di buram" (the history of Abraham?). In 1469, Lazzaro Bastiani began the history of David; and in 1470, Bellini agrees to do "el deluvia e larcha di Noe (the deluge and the ark of Noah), with all its appurtenances on the modes and conditions

33

of the pact with ser Lazaro Bastian in each and every particular."[3]

Of Bellini's manner in these large historical compositions, both in the *scuole* and in the Ducal Palace, we can form no idea; except for Vasari's description of the latter, all trace of them has disappeared. The next two works which we shall consider are evidence of Bellini's having kept up his father's connection with the patrons of the Marches. They are the *Transfiguration* (now at Naples) and the great altarpiece still in the church of S. Francesco at Pesaro, for which he executed it. It will be remembered that Anna, Jacopo's wife, came from Pesaro, and it may well have been through her family that the commission for this altarpiece was given to Giovanni.

As the altarpiece is of great size and on wood, it was probably painted on the spot. Now, to get to Pesaro, Bellini would be almost certain to go through Ravenna; and the fact that the tomb of Theodoric and the tower of S. Apollinare in Classe, two of the strangest sights of that town, occur in the background of the Naples *Transfiguration,* makes it not unlikely that he executed this picture on his way to Pesaro. We shall see reason later on for giving to the predella pictures of the Pesaro altarpiece so late a date as 1481; but there is nothing to prevent the supposition that these small pictures were dispatched subsequently from Venice, and that both the *Transfiguration* and the altarpiece itself belong, as the evidence of their style would suggest, to the latter half of the eighth decade.

In the *Transfiguration,* compared with the earlier treatment of the same subject, the change of feeling is very marked. The dim twilight which surrounds that terrible appeal for sympathy is exchanged here for the glow of a late autumn afternoon, and the lonely mountain for a rich pastoral land. Both in the sentiment of the landscape and its relative prominence, it approaches Jacopo's designs. But though more charming than the earlier *Transfiguration* it is none the less a profoundly imaginative rendering of the

subject, strongly impressed with that equable common sense, that absence of all extravagance or ecstasy, which were so valuable a part of Bellini's Venetian inheritance, and which distinguish him among other fervently religious artists.

For there is no trace of mediaeval symbolism here. To anyone who understands the universal language of pose and gesture, it is evident that these three men—real men who walk the earth with palpable tread—are suddenly perceived by their amazed companions to be of more than human build, are heard to converse with the large serenity of gods. The idea of the invasion of this actual material world by a divine presence has surely never been realised with so intimate an imagination as here. Already in the *Agony in the Garden* we noticed how much Bellini anticipated modern art in the expression of a feeling towards nature that is usually assumed to be modern, but which is probably constant in human nature; and here we have not only a consistent and accurate presentation of the hard light which accompanies heavy, white cumulus clouds in the horizon, but a quite Wordsworthian delight in the details of plant forms.[4] It has already been suggested that this work comes after a considerable gap in the sequence of Bellini's works; and in the interval an important change has taken place in his technical processes. In all the works here ascribed to the sixties, Bellini, although he had abandoned the Paduan system of design, and was aiming at tender gradations of modelling, instead of complexity of outlined forms, was still obliged to continue the old Paduan tempera technique, in which light and shade were put on by small hatched strokes with the point of the brush. It is evident that such a method was ill suited to Bellini's purpose; and even if Vasari had not told us[5] that the artists of this period were keenly desirous of an improved method, we should have suspected that he would accept with delight any discovery which enabled him to gradate his tones by an actual fusion of them one with another upon the surface of the panel. Such a fusion was impossible with the old quickly drying tempera. Now in 1472

Antonello da Messina appeared in Venice, bringing with him, we need not here discuss whence, the knowledge and practice of a technique which admitted of perfect fusion of tones.[6] This technique consisted in part in the superposition of thin layers of opaque colour mixed with oils. From this time onward, all the more advanced artists[7] of Venice succeeded in obtaining fusion, and dispensed with hatching, except in rare cases, when it was used in retouching. But it would be rash to assume that they adopted Antonello's oil technique altogether; his thin layers of opaque paint were ill suited to produce the rich impasto which they desired; and we know, both from documentary evidence and the inspection of the pictures themselves, that they continued to paint in tempera,[8] though they began to use thin glazes of transparent oil over the solid tempera foundation. But even where this was not resorted to (and the Pesaro picture which we shall now consider is certainly without glazes), some at present unknown method was discovered, by which tempera could be handled so as to imitate the fusion of oils.[9]

The altarpiece at Pesaro is the first of those large altarpieces on which, more than anything else, Bellini's contemporary fame rested; it was the first time, so far as we know, that Giovanni or Gentile Bellini had competed in the special province of the Murano school; and this was one of the first altarpieces in which the old ancona form was replaced by a more modern arrangement. The arrangement here is unique, and singularly fitted to bring out to the full Giovanni's powers as a landscape painter. For here the landscape (with its towers lit by the rays of the setting sun relieved against a sky of gold barred with purple clouds) has, by virtue of the carved marble frame which encloses it, something of the unfamiliarity and impressiveness of a landscape seen unexpectedly in a mirror. It is natural to speak first of the landscape, because at first sight the coronation itself and the attendant saints seem almost accessory to it. But they are, none the less, among the most sublime of Bellini's creations, and give us an

insight into a new aspect of his character as a painter.

For though the feeling is still distinctly religious, it is more dis-tant, more aloof and impersonal, than heretofore. And with that aloofness on the artist's part from any one emotional *parti pris,* there comes a wider range of sympathetic observation and the power of conceiving and visualising a number of distinct types with varying ranges of emotions. It is by such an art that the mir-ror is held up to nature; not by the construction of a single abstract type of ideal beauty, nor by the careful imitation of individuals, but by the construction of a world of perfectly realised and con-crete types, more complete than any one individual, by which we apprehend, and to which we refer a number of individuals. Such an idea of art, as reflecting the richness and many-sidedness of nature, was comparatively rare in Italy: Titian was perhaps the greatest, certainly the most Shakespearian exponent of it; and here already Bellini is Titian's forerunner. The S. Francis is the least aetherealised, the most human conception of the man in Venetian art, and the most convincing in its rendering of spiritual passion. The S. Jerome is a perfect expression of the dogmatic the-ologian whom the abstruseness of his studies has cut off from human intercourse; but it is in the S. Paul that Bellini's concen-trated realism is most felt. Even he never conceived anything more convincingly self-consistent than this imposing figure, per-fect alike in the slow gravity of its movement and in the large design of its drapery, but most sublime as an expression of a rare type of character, in which the saint and the man of the world are harmonised. The organiser of Christianity might well have been a man of such rapid insight, such a plausible and imposing pres-ence, so gifted, so polished, and with such power to command, as Bellini has here conceived him. Except that the composition has lost the figure of God the Father at the top, it has been but little touched; and the predella pictures are in their places. In these the most important event of the lives of the attendant saints in the altar above are presented in order. Under the figure of the S. Paul to

37

the left is represented his conversion; and in this lies the key to the date of the execution of the predelle, for, whatever date we may assign to the altarpiece itself, it is difficult to resist the conclusion that this picture was done after Gentile's return from Constantinople in 1481. It is not merely the fact that the attendants have Oriental costumes,—such Oriental costumes occur as early as the Eremitani frescoes,—but that the Orientalism has that minuteness and verisimilitude that we find in Venetian pictures only after Gentile's return. The jack-boots of S. Paul, with their peculiar wrinkles, are entirely in Gentile's manner; the jerkin is certainly not Venetian, and is probably some Byzantine costume; but it is in the horses that we find the most convincing proof of the knowledge of Gentile's Eastern sketches. The horse in Italian art before this time was always the destrier; this horse, peculiar for its small compact build, is not indeed the Arab horse, but it is the horse (possibly a descendant of the Greek horse of which we are here forcibly reminded) which is to be found to this day in the uplands and mountainous districts of Turkey.[10] The horse given here, the saddle with its curious curve up at the back, and the peculiar triangular stirrup, are all to be found in Gentile's *Adoration of the Magi* (Lady Layard's Collection, Venice), where we find a horse (to the extreme right) which may almost have been the original of S. Paul's horse here; and it was in that picture that Gentile took advantage of the subject to display his Eastern acquisitions.

In the figure of S. Paul himself Bellini has failed, as he not unusually does, to suggest convincingly sudden or vehement movement; but in the attendant above, he has discovered a pose which is equally fine for its dramatic appropriateness and for its relation with the pose of the horse. It is from this and the two adjoining predella pieces that we can alone form some idea of what Bellini's large historical works may have been like; for they are the only remaining works that have strong dramatic action. Though in each case the story is well told, there is nothing to make one suppose that Bellini ought to have been a dramatic

38

painter; and even here it is in the invention of the landscape that Bellini surprises us most. In the S. George both the composition (with the centre of interest confined to one corner of the design) and the action of the horse are like Jacopo's frequent sketches of the subject. The princess shows an anticipation of Carpaccio's fantastic costumes.

To the eighties belong a large number of Bellini's existing works. His fame as a designer of large altarpieces in the modern manner was by this time established, though already in 1480 Alvise Vivarini had left the old Muranese tradition, and composed an altarpiece in which the various figures appeared as related to one another by a more consistent and logical scheme of light and shade than even Bellini had aimed at.

Our understanding of Bellini's development at this period is much obscured through the loss by fire of his great altarpiece in SS. Giovanni e Paolo. The loss occurred in 1867, just a few years too soon for us to have even a good photographic record (the reproduction here is from a photograph of a poor water colour copy). This picture, considered by those who knew the original as one of the finest of his altarpieces, was ascribed in the old guide books to the year 1472; but apparently solely on the ground that, being in tempera, it must have been produced before Antonello came to Venice. The study of prints, and the reproduction here given, makes it improbable that it belongs to an earlier date than the last two pictures discussed here;[11] and the full rounded ovals of the faces and the long folds of the drapery make it probable that it should be placed in the first half of the ninth decade; that is to say, between the Pesaro altarpiece and the great altarpieces of the next five years.

Another reason for this may be drawn from the architectural setting, which is in the style of the Lombardi, who began to work in Venice about 1480. In the saint reading we can imaginatively reconstruct another of Bellini's perfectly realised and complex types, in which saintliness by no means interferes with mundane

39

accomplishment, a type with which it is interesting to compare Titian's S. Damian in his S. Mark of the Salute. A number of motives occur here for the first time, which were adopted not only by Bellini's followers but by the members of other Venetian schools. For instance, the open loggia with the hanging lamp occurs in Montagna and Cima; the drapery and waistbands of the putti occur in Alvise Vivarini and even in Bonsignori. The beautiful floriated embroidery on the breasts of S. Ursula becomes a favourite motive with Cima, Carpaccio, and Diana; while Titian himself may have got from this the idea of the laurel-crowned banner in his Madonna at the Frari.

Two small Madonnas may be associated with this picture, one the *Madonna with the Child* standing in the act of benediction in the Venice Academy, and the *Madonna and Child* at Turin, in which Bellini has employed the same cartoon for the Madonna, altering it somewhat perfunctorily to accommodate a sitting child; a proof that at this time Bellini's commissions outran his powers of execution.

To the next five years belong an extraordinary number of Bellini's works, the chronological order of which can only approximately be established. They will be grouped here by their technical affinities, by the gradual increase of the sense for atmosphere, and by the types of the Madonnas' heads; for Bellini has by this time become so realistic that the various models can be easily traced.

We will divide the remaining pictures of this decade into four groups—(1) Pictures associated with the Frari triptych; (2) the S. Giobbe altarpiece; (3) two pictures belonging to the year 1487; (4) the altarpiece at Murano.

There is, no doubt, one serious difficulty in placing the Frari group at the beginning of the series, and that is the fact that it bears the date 1488, the same date as the Murano altarpiece; but a comparison of the two pictures makes it impossible to suppose that both were painted in the same year, and we must, I think, assume

that the Frari triptych was conceived and planned out, and for the most part painted, several years earlier (about 1485), and that the date 1488 refers to its final finishing and delivery. The reason for giving this first group so early a date is that the pictures belonging to it exhibit the final perfection by Bellini of that technique of fused modelling within a perfectly firm and unbroken outline which we associate with Antonello da Messina's influence; whereas in the S. Giobbe altarpiece we find the first step towards that treatment of form as enveloped in atmosphere, which Bellini pursued with increasing success to the end of his life, and the perfection of which is one of the chief distinctions of cinquecento painting in Venice.

Let us now attempt an arrangement of the pictures of this first group.

First of all, and probably before 1485, we have the *Madonna* of the National Gallery, in which the "tightness" of the contours, the almost wooden modelling, and the arrangement of the drapery suggest Bellini's earlier work.

Next comes the far more sensitive *Madonna* in the Morelli Gallery at Bergamo, in which only the careful precision with which the folds of the child's flesh are delineated reminds us of early examples. The hand of the Virgin, for instance, already shows that tremulous sensitiveness which becomes positive weakness later on. In the landscape we have the first example of an idea which becomes universal with Bellini's pupils of the sixteenth century.[12]

In the Frari Madonna we have the highest point to which richness of light and shade imposed upon a firm outline can go. Technically it is one of the most perfect and also one of the best preserved of Bellini's works. Painted in thin flat layers of colour, with hardly any impasto, it comes nearer to Antonello's technique than any other work, though in the sweetness and mellowness of its rich harmonies it far surpasses that master. Even in Bellini's works it would be hard to match the depth and richness of these

colours, or to find contrasts so forcible and yet in such perfect harmony, as, for instance, between the yellowed ivory of the vellum missal and the black of the saint's robe, a black which is not the absence of colour but rather the quintessence of all rich colours so concentrated as to be invisible. It is surprising that Bellini practised so little a technique which led to such a splendid result.

Bellini's changed attitude towards his subject has by this time become very noticeable; compared with the intensity of adoring and fearful love of the Brera Madonna, this beautiful young woman shows little more than placid contentment; nor do the Christ-child and the two sophisticated putti interfere in any way with the air of well-being and delight in existence that pervades the whole composition.

The same model as that in the last picture, with the full rounded oval, the prominent eyes, slightly retroussé nose and small mouth, appears in the *Madonna between Saints Catherine and Mary Magdalen* (Venice Academy). There is also the same thin flat treatment of paint without impasto. The illumination and the colour scheme are peculiar, and appear to have been suggested by a lamplight effect. The way in which the local colours are all modulated to a single key of rich golden brown is an anticipation of Titian's art of arousing the sensation of colour by a varied monochrome. Here, for instance, so perfectly is the key kept throughout, that the periwinkles in S. Catherine's hair appear blue, although the actual pigment is almost a brown grey.

The replica of this picture at Madrid shows several alterations, which suggest that it was done at a later date. The signature has the second L longer than the first, and it appears (so far as the author can tell from a photograph) to be genuine, though in very bad condition.

The same model as served for the Frari triptych and the last picture reappears in the *Madonna with a Choir of Cherubs* (Venice Academy). The picture is much repainted; but even allowing for that, it would appear to belong to a slightly later date than the oth-

ers of this group, and to indicate a momentary return to the model and poses habitual in the works of this group. The pose of the child is like that in the *Madonna* in the Morelli Gallery at Bergamo; while the action of the hand, gently pressing the finger tips against the child's body, which was first seen in that work and repeated again in the Frari triptych, has become exaggerated into nervelessness. Here again there is a conscious attempt at a strange effect of light, this time of early dawn, the pale apricot glow in the sky indicating the exact moment when the white of the Virgin's head-dress becomes luminous, though the flesh is still dull in tone.

The charming conceit of the choir of cherubim amusing the infant Christ (now entirely human), as they flutter in the dull blue of the twilight sky, marks the change in Bellini's feeling.

The group of pictures we have just considered closes the second stage of Bellini's artistic career. During this period his aim was to obtain perfectly modulated transitions of tone within a precise contour. In the S. Giobbe altarpiece, which we may assign to about 1486 or '87, a new idea begins to be felt—the conception of enveloping the forms in atmosphere by means of a subtle variation of the quality of the limiting contours of the figures. This atmospheric envelopment of form is primarily a beauty of the surface quality of the picture, and not a matter of the scientific analysis of natural appearances; and though the richest effects of chiaroscuro cannot be obtained without it, it is quite distinct from the study of consistent arrangements of light and shade. Alvise Vivarini far surpassed Bellini in his research into the problems of light and shade; but lacking his sensitiveness both to beautiful tonality and to beautiful surface quality, he never acquired Bellini's atmosphere.[13]

In composition the S. Giobbe picture is not the most perfect of Bellini's big altarpieces. The deep frieze, with its heavy mouldings, and the thick ornate pilasters, deprive it somewhat of the sense of space, which the open loggia of the lost altarpiece must have had. The great problem in the grouping of saints symmet-

43

rically at the base of the throne was due to the straight line made by the heads of the saints being crossed at right angles by the uprights of the throne. Alvise Vivarini solved it by the ingenious device of raising two of the saints on a step, so as to obtain a pyramidal arrangement. Bellini here places the line of sight on a level with the bottom of the picture, so low that the heads of the saints standing back from the picture plane come well below the heads of those in front. In the group to the right this is satisfactory; in the left-hand group it results in the rather awkward concealment of the whole of S. John's body. Bellini's attitude is here increasingly impersonal. His delight is not in the expression of profound emotion, but in the creation of types, with a view to their pictorial possibilities more than their significance as expressions of religious ideals of character. It is the contrast between the aristocratic and youthful S. Sebastian, who has swaggered in to the sacred assembly, and the figure of the S. Giobbe, in which neither age nor asceticism has destroyed physical beauty, that absorbed the artist most. And in the treatment of these nudes Bellini has found his interest more in the beautiful surface quality of the flesh than in the study of pure form or the relations of the planes. Compared with the scholarly research of his Berlin pietà, the line here, though its general direction is admirably felt, is somewhat summary; and the modelling (*e.g.* in S. Sebastian's thighs) shows but little research. Like the earlier altarpiece of SS. Giovanni e Paolo, this became a mine of pictorial motives. Bellini himself used the poses of his nudes again; both Giorgione and Titian were indebted to the S. Francis; and the music-making angels gave Carpaccio the hint for one of his best figures—the one at the base of his altarpiece originally in the same church.

Two pictures of the year 1487 show just that advance in the command of the newly acquired quality of atmosphere that we should expect. The type of Madonna in these is again changed: in her thinner, oval, and smaller lower jaw she resembles an earlier type. It is certainly a more tender, less indifferent and super-

44

cilious, beauty than that of the S. Giobbe Madonna or the Murano one of the next year.

The second picture, the *Madonna between Saints Paul and George*, is developed out of the last, the same contour being used for the child's body, though the head has afterwards been turned round with some evidences of the discrepant movement. The type of child here is very near to that adopted by Giorgione in his Castelfranco Madonna. Giorgione's peculiar romantic sentiment, though not his forms, is already suggested here in the S. George, above all by the mysterious quality of the armour, which is very different from Alvise's straightforward and merely workmanlike painting of a similar motive in his Berlin altarpiece.

In the *Madonna and Doge Barbarigo* at Murano, sadly repainted as it is, we can still perceive an increase of all those characteristics which belong to Bellini's final manner; the angel on the Madonna's left is modelled entirely in a luminous shadow, a treatment which shows a new power of subordination, and consequently a new power of unification of the whole composition. The castellated hill in the distance is line for line the same as that in the background of the Pesaro Coronation, though seen from a greater height. But, so far as the author is aware, this has not yet been identified with any known place. A new design of drapery makes itself apparent here for the first time, in which the drapery falls in a straight line from the head to the feet. The Olympian calm and self-possession of the Madonna, and the purely ceremonial prostration of the Doge, are striking examples of Bellini's later feeling.

1. In an earlier version of the subject in the Ducal Palace Jacopo's design is closely followed. This picture was enlarged both at the top and bottom, and turned from a flat-arched picture into an oblong in the year 1571, when the whole of the background was renewed. It is almost impossible to fit the picture as it stands into the sequence of Giovanni's development. There are in it traces of the primitive Venetian type of head met with in Giambono, and which appears in Gentile's organ shutters, but except for this

pietà nowhere in Giovanni; and yet in some respects the forms belong to a later period.
2. Here, as in the early pietà in the Correr, the composition is foreshadowed by a bas-relief by Donatello; the Christ supported by angels in the South Kensington Museum.
3. It looks as though Bellini's fame was of slow growth, when he is thus put on a level with so inferior a painter as Bastiani.
4. This is quite distinct from the purely decorative and summary abstractions of flowers which were usual among quattrocentist painters; only Leonardo and Bellini studied flowers like this.
5. Life of Antonello da Messina.
6. His picture of 1465 in the National Gallery proves him to have possessed the knowledge of this at a time when no Venetian, probably no Italian, had any idea of how to compass this end.
7. Bart. Vivarini continued the old methods.
8. See Carpaccio's letter in Molmenti's "Carpaccio son oeuvre et ses temps."
9. It is not unlikely that the knowledge that complete fusion was possible in oils might force artists to modify the tempera technique, which suited them better in other ways, so as to keep pace with the improvements of Antonello's oils.
10. The author is indebted to Mr. Lynch for this confirmation of a view originally suggested to him by Prof. Wooldridge.
11. The drapery of the Madonna's knees is very near to that of the Christ in the Pesaro Coronation.
12. The same horseman rides past in the background of the Madonna in S. Francesco della Vigna (1507) and the Madonna in the Brera (1510).
13. Unless perhaps in the Resurrection in S. Giovanni in Bragora; but in his last work he returned to his old slippery hardness of surface.

VIII. The Allegorical Pictures

*A*fter 1488 there comes a gap in the sequence of Bellini's altarpieces, which begins again with the S. Zaccaria picture of 1505. The interval was occupied largely by Bellini's works in the Ducal Palace. But before proceeding to pictures dating from the sixteenth century, we must notice two important works—the allegories of the Uffizi and the Venice Academy, of which the former is of capital importance for its evidence of Bellini's unique position as the pioneer of cinquecento art, while both alike are interesting as belonging to that series of pictures in which Bellini, casting off for a moment the symmetrical regularity of the altarpiece, showed that he kept alive the tradition of Jacopo's free composition and his lyrical fancy; a tradition of which Giorgione was so soon to find the highest possible expression. It becomes therefore a matter of some importance to fix as nearly as possible the date of this poetical conception. The prominence given to the contrast between S. Sebastian and S. Giobbe reminds us forcibly of the S. Giobbe altarpiece; but the likeness goes even further, S. Sebastian here repeating very closely the pose of S. Giobbe in the altarpiece, while the legs of that saint resemble in movement S. Sebastian's in the other picture. Another reason for giving this work such an early date, is that the drapery of S. Peter, with its numerous nearly parallel folds arranged in curves, but with sharp angles in the small folds, is of the same type as that in the Frari Madonna and the playing angels of the S. Giobbe picture; a type which has disappeared entirely in the pictures of following years. Again, the child in the centre, shaking the tree, is

47

like the child of the Frari picture in his sturdy, well-planted feet, a characteristic which is usually wanting in the later children.

It must be admitted, however, that the fineness and elegance of the S. Lucy, to the extreme left, belong naturally to Bellini's later works. The question is whether Bellini has here had a pre-monition of a type he was to develop later on, or whether the affinities with the works of 1485 and '86 are reversions in later years to earlier methods of design. It would be rash to dogmatise; but on the whole, the former seems the more probable, when we consider how constant Bellini is in the forms of his drapery. To accept such a view leads no doubt to very surprising results, for Bellini has here attained to the complete envelopment of form in atmosphere; for the first time in Venetian art[1] we can imagina-tively feel right round each form, and pass behind it into the free space of air by which it is surrounded. It is no longer linear per-spective only which tells us, for instance, that the Madonna's head is separated by a space of air from the lake against which it is relieved. As we know from Pietro Aretino's letters to Titian, this atmospheric quality was, with the artists of the next generation, a matter of conscious and elaborate research; and it was Bellini's unparalleled sensitiveness to beautiful quality which showed the way. For here the atmospheric effect is not so much a matter of scientific analysis of the effects of nature, as a perception that thus and thus only could the intensest unification of the picture be effected, and that thus only could the beauties of transparent paint find their fullest display. For the atmospheric quality is obtained here largely by the use of oil glazes upon a tempera ground; it is by these that the shimmer of vibrating air is communicated to the whole, by these that the contours, on which the design is still built, are broken down, so that the eye is no longer arrested, as in earlier art, by the impassable barriers they present. Nor are these technical changes without their significance as an indication of the change in Bellini's feeling; for the mood which pervades this mysterious vision of a rock-bound lake, in whose opalescent

48

depths the evening light still lingers, is one of pure and unquestioning delight in the sensuous charm of rare and beautiful things. And yet, curiously enough, nothing shows more conclusively that Bellini's conscious imagination remained mediaeval; that the ideas and feelings that he formulated to himself still belonged to the Middle Ages, though in the deeper layers of his consciousness the ideas of the new age already predominated.

For Dr. Ludwig, to whose forthcoming book on Iconographic Studies in Venetian Art the reader must be referred for details, has found that the explanation of this picture carries us back to a pre-Dantesque Divine Comedy, *Le Pelerinage de l'Ame* by Guillaume de Guilleville. The railed-in space is the earthly paradise, where souls, represented as children, shake down fruits from a tree, the mystical tree of the Cantus Canticum. Saints Peter and Paul guard the door, while the hermit across the water indicates the life of asceticism and resistance of temptation (typified by the centaur), by which alone the probation of purgatory is lessened.

A similar contrast between the intellectual conception and the artistic treatment is evident in Bellini's allegories in the Venice Academy, in which, in spite of the apparent classicism of the forms, Dr. Ludwig has recognised a traditional series of mediaeval allegories. It is evident that these were painted by Bellini in the slight and almost casual manner that would be natural to a great artist in executing a small decorative work as a relaxation in the midst of more serious studies; and it is a natural conjecture that they were the panels done by him for a cassone, mentioned in the will of his pupil Catena.[2] Originally somewhat hastily painted, and now seriously damaged by the leaden opacity of repaint, it is only in the general design that Bellini's exquisite fancy is felt. A comparison of the tower surrounded by water in the "Fortuna Inconstans,"[3] with the exactly similar motive in the S. George and the Dragon of the Pesaro altarpiece, will show the inferiority of the later work. In the Prudence (usually called

Truth) we have the only example of a female nude in Bellini's works, remarkable for its approximation rather to the mediaeval type of Riccio's Eve in the courtyard of the Ducal Palace, than to the classical types which influenced Giorgione and Titian.

The improvised quality of these paintings makes it difficult to fix their date by considerations of technique; but they would appear to be later than any works we have considered so far, though the likeness of the landscape in the central panel (Summa Virtus, according to Dr. Ludwig) to that in the Madonna of 1487, suggests that they are probably not later than the early nineties.

1. But for Leonardo da Vinci one might say, "the first time in modern art."
2. Crowe and Cavalcaselle, *History of Painting in N. Italy,* i. 259. "Item laso al sovrascritto...el mio restelo di nogera chon zeste figurete dentro de miser Zuan Bellin."
3. According to Dr. Ludwig, the panel usually called "Venus holding the world" represents "Fortuna Inconstans," and the putti typify the various conditions of good or evil fortune.

IX. Works of the Sixteenth Century

O ne of Bellini's duties as State painter was the execution of official portraits of the Doges, of which only that of Loredano (National Gallery) remains. A comparison with Catena's portrait of the same Doge (Ducal Palace) done in 1508 would lead us to assign Bellini's to the first five years of the century. It is the only portrait by Giovanni that exists. In composition, in colouring, and in characterisation it is admirable, but it lacks the concentrated linear design of his brother's portraits.

In the intervals of Bellini's work at the Ducal Palace he painted, between 1501 and 1504, a picture for Isabella Gonzaga, Duchess of Mantua.[1] Already, in 1493, she had visited Venice and obtained the promise of a view of Cairo from Gentile. Her relations with Giovanni begin with the year 1501, in which she writes to her agent in Venice, Vianello, to get Bellini to do for her studio a picture of which the subject was to be profane, a story or mythological conceit ("istoria o fabula antiqua"), to suit Mantegna's allegories. Bellini agreed to undertake the work, and the earnest money of twenty-five ducats was duly sent. But then the difficulties began. First of all Bellini humbly suggests that he cannot do such a subject in a way to compare with Mantegna; that he wishes to do his utmost, and that with such a subject "he cannot do anything to look well," and that he would undertake it "as unwillingly as he can possibly declare." The agent wisely puts in a word on Bellini's side in transmitting this, and with some regret Isabella is content to put up with a religious subject: first a "presepio" is agreed to, but then the Duchess wants continually to add

51

figures which will increase the romantic charm of the composition. Bellini changes the subject, holding out against the introduction of an adult S. John Baptist in a presepio, and begins at last, but not till after nearly two years' correspondence, a subject of the Madonna and Child with many saints, among which occur S. John Baptist and S. Jerome, for which the Duchess had pleaded in the hope of fixing thereby the poetical character of the work; and the whole was to have a distant landscape and other fantasies ("qualche luntani et altra fantaxia").

By 1504 Bellini had finished the picture; but the Duchess was so incensed at the delay, that at first she refused to have it, and began to take steps to get back her earnest money. But an almost pathetically humble letter from Bellini himself, and the extreme enthusiasm of her agents for the work, induced her to reconsider her verdict; and the catalogue of her Mantuan pictures in 1527 records "un quadro lungo braccia tre circa, di Giovanni Bellini con una B.V., il Putto, S. Giovanni Battista, S. Giovanni Evangelista, S.Girolamo e Sta. Caterina sul asse" (on panel).

The chief importance of this incident is in showing that, however far Bellini had lost the passionate fervour of his early religious paintings, he still considered himself as an exclusively religious artist. But how far he was able to import into a religious picture the new feelings of untroubled delight in sensuous beauty, is seen by his next great work, the altarpiece of S. Zaccaria.

Between this altarpiece, dated 1505, and those of the ninth decade of the previous century, Giorgione's genius had matured; and the revolution in art, which Bellini had so long prepared, was proclaimed by his Castelfranco Madonna of 1504. In that work Bellini's great pupil had shown that the new command of atmospheric tone and rich chiaroscuro were consistent with, and even demanded an entirely new simplification of design, and a new feeling for large and spacious disposition of masses. Whether stimulated by the resplendent results of his pupil's genius, or merely carrying out the natural trend of his own development, Bellini

shows at last in this altarpiece the perfect solution of the problems involved in the idea of the enthronement of the Virgin, which had become traditional in Venetian art. Compared with the S. Giobbe altarpiece the architecture is lighter and more elegant; and the great advantage of raising the line of sight is evident in the increased depth of the figures within the picture. The figures here move in an ample space; and the large voluminous folds of the drapery, which in the Madonna's robe fall for the first time over the step of the throne,[2] emphasise the reposeful suavity of the composition. But, however much Bellini in these matters is working in the same direction as Giorgione, Titian, and Palma, in the types of the faces his feeling is very different from theirs. Instead of the Classical regularity and massive features which were common with the young generation, Bellini has here perfected that fragile and flower-like type which we saw for the first time in his sacred allegory of the Uffizi. Indeed, at this stage of Bellini's development everything is subordinated to sweetness and grace. All his early intensity of feeling, the regal stateliness of the Madonnas of his middle life, are here fused and mellowed in the glowing atmosphere of the new cinquecento art. Bellini was now nearly eighty years old; and yet he comes forward with a new conception of the altarpiece, a new system of design in drapery, new types of face, a new scheme of colour. It is an alternative presentation of the Renaissance spirit to Giorgione's; less serious, less intense, more purely charming than the younger man's, lightened as it is by the humour of a wise old man. It is, no doubt, more in touch than the Castelfranco Madonna with the older traditions of art; but it is just as rich an expression of an untroubled delight in existence. Certainly the purely sensuous enjoyment of colour can find no more complete gratification than Bellini has granted here.

Up to this point, then (1505), Bellini had advanced, step for step, with his artistic offspring; but it was impossible, even for him, to go on after his eightieth year moulding his art to the expression of fresh beauties; and for the rest of his life he was con-

tent to continue painting the old subjects with so much of the new feeling as he had already discovered. The pictures of this last period vary much in excellence; sometimes, as in the Baptism at Vicenza, and the Madonna of S. Francesco della Vigna, the form gives way under the stress of his research for colour and atmosphere; sometimes he reasserts himself with something of his early vigour beneath his newly acquired charm.

It is not exactly clear what Bellini's attitude was to the Giorgionesque art; but there are signs that he, and still more the large school of pupils who had begun to gather round him at the end of the previous century, opposed it with all the vehement conservatism of an official and academic party. The superiority of the new art was by no means self-evident to the Venetians; and the Giorgionesque artists had often to look to the mainland for patronage. In fact, the altarpiece of S. Zaccaria afforded an expression of Renaissance ideas which was more sympathetic to the conservative Venetians, by reason of its ostensibly religious character, than the revolutionary neo-paganism of Giorgione and Titian; and it is not a little surprising to find that most of the art which was produced by Bellini's pupils was derived from his style as shown in the S. Zaccaria altarpiece, and not from the Bellini of the quattrocento. Catena's earliest work at Padua, for all its rugged severity, derives, as its drapery and the poses of the hands show, from Bellini as he must have been at the very end of the fifteenth century. Bartolomeo Veneto's earliest work belongs to the same year as the Zaccaria altarpiece; and we may doubt, when we consider the want of accomplishment of Catena's *Doge Loredano kneeling to the Virgin*, in the Ducal Palace, whether he did not enter Bellini's workshop later than Giorgione and Titian.

And, moreover, the manner that was thus derived from Bellini's great altarpiece of 1505, and from lost works of the preceding years of the century, was not supplanted by the Giorgionesque art till after 1520; ten years after Giorgione's and four years after Bellini's death. During all this time there were two

54

rival schools, both practising an essentially cinquecento manner, but practising alternative versions of it; and we may judge how keen the rivalry between the two was, from the efforts made by Titian to get State recognition, and the machinations of the official Bellinesque party to keep him out of the Ducal Palace.[3]

From 1505 onwards we have, then, no definite advance to record, and it will be sufficient to recount shortly some of the chief events of the rest of his life.

To the year 1507 belongs the Madonna in the church of S. Francesco della Vigna. In the same year Gentile Bellini died, leaving to his "well-beloved brother" their father's sketch-book, on condition that Giovanni should finish the picture on which Gentile was engaged at the time of his death, namely, the preaching of S. Mark at Alexandria, a condition duly fulfilled by Giovanni.

To the year 1510 belong two pictures, a *Madonna and Child* in the Brera, in which the elegance of gesture and the voluminous drapery cut into facet-like folds, which first appeared in the altarpiece of 1505, are well exemplified; and the great *Altarpiece* at Sta. Corona in Vicenza. This picture gives rise to an interesting question of critical casuistry. The altarpiece represents the baptism: now, sixteen years before, Cima da Conegliano had painted for the church of S. Giovanni in Bragora an altarpiece with the same subject; and the two pieces bear such a resemblance, that, had Bellini's been the earlier picture, no one would have hesitated to consider that he had influenced the younger man. But it is harder to believe that Bellini at eighty should be influenced by so much younger an artist as Cima; and, given the subject, the constant tradition of its treatment throughout Italian art might lead each painter separately to a similar composition. On the other hand, it must be borne in mind that the adoption of the subject at all for a big altarpiece, implying, as it did, a break with all the traditions of Venetian altarpiece-making, was a startling and, up to 1510, a unique venture on Cima's part. And there is nothing unnatural in supposing that Bellini, struck with the possibilities of Cima's

idea, made up his mind that when a fitting occasion presented he would do an altarpiece on the same lines. Such influence as that, concerning itself mostly with the intellectual[4] antecedents of the artistic vision, is possible at all times of an artist's life, without reference to the superiority either in age or talent of the artist from which it is derived.

In spite of the fact that the Baptist, and to some extent the Christ, show the worst faults of his later drawing,—the weak, unstructural poses, the nerveless hands and heavy feet,—still, in the attendant angels, Bellini has almost surpassed the dainty and flower-like beauty of face and gesture of the saints at S. Zaccaria; while in the landscape, though the structural modelling of earlier years is conspicuously absent, Bellini has replaced Cima's delightful but irrelevant pastorale with a sombre and sonorous accompaniment, in which his sense of mood in landscape is more clearly demonstrated than heretofore.

The figure of the Almighty in this picture is of interest, as being almost identical with an isolated figure in the Municipio at Pesaro, first recognised by Mr. Berenson, which may belong to some lost altarpiece of a rather earlier date, of which no account has reached us.

To the year 1513 belongs Bellini's last indisputable work, the altarpiece in S. Giovanni Chrysostomo at Venice, in which the highest characteristics of his art receive a final and sublime consummation. Bellini here retains something of the formal symmetry of the older altarpieces; he retains too the architectural setting (with the Byzantine decoration and Greek lettering which he affected throughout his life); but we look through the arch upon the strangest, most romantic enthronement ever conceived—an old hermit,[5] who has grown by long years of secluded contemplation into mysterious sympathy with the rocks and plants and trees of his mountain solitude, sits in a scarlet robe, silhouetted upon a golden sunset sky, across which faint purplish clouds are driven by the wind; and below him there spreads a vast expanse

of valley and mountain ridges. Bellini's intimate Wordsworthian feeling for the moods of wild nature finds here its remotest and sublimest expression. And if the drawing still shows traces of quattrocentist methods, if the chiaroscuro is not so rich as Titian's and Giorgione's, still in the consistent elaboration of a particular passing effect of atmosphere, Bellini has gone beyond what his pupils accomplished. It is only in the landscape art of the beginning of the present century that we can find a scene thus entirely modulated to the dominant key of a sunset light.

One other picture remains to be mentioned. In 1514 the Duke of Ferrara paid Bellini eighty-five ducats for a picture which was finished in that year.[6] It is probable that this was the *Bacchanals,* now at Alnwick Castle.

On the vexed question of how much of the actual execution of this picture is due to Bellini's pupils, the author, who has not been able to examine it, can say nothing; but the fact that a composition so entirely conceived in the neo-pagan spirit of cinquecento art came from his atelier with his signature proves how completely Bellini, at the very end of his life, accepted formally a sentiment which had for long governed the unconscious workings of his imagination.

In conclusion, a few words must be said about the general impression of Bellini's works; about those characteristics of his artistic temperament which remain constant throughout all his changes both of technique and feeling. After what has been said by way of introduction with regard to the Venetian temperament, the statement that he was a typical Venetian will convey a general idea of Bellini's nature; a nature in which a feeling for sensuous charm is guided rather by the intensity of his human feeling than by any great intellectual ideal. His feelings too, for all their intensity, are controlled by an exquisite and instinctive judgment, by a reasonableness which is itself a feeling rather than a dialectic. His expression of certain emotions is as poignant as any in the whole range of art, but it is never ecstatic or excessive; with

57

him sorrow is never desperate, compassion never effeminate, nor does the tenderest affection ever verge on sentimentality.

But his rendering of emotion is not that of a dramatist, capable of realising imaginatively the whole range of human passion; nor has the event any interest for him. His pictures each render a single emotional state; and that in his earlier works is almost always some phase of the emotions of pity and love. In all his versions of the Madonna and Child the exact shade and variety of the feeling are perfectly explicit, and almost always distinct; and the richness of his invention is shown by the perfect harmony of the particular feeling expressed by the mother with the pose and expression of the Child.

In his early works, then, pathos is the dominant emotion; and even in his later ones, for all their genial serenity, there is an undercurrent of the same feeling. But the pathos which his figures express is never sickly or sentimental; rather it is, as Bellini feels it, the inevitable result of their condition as human beings; and if a single phrase might stand for what Bellini has expressed more intimately than any other artist, it must be Virgil's—

"Sunt lachrymae rerum et mentem mortalia tangunt."

1. For this episode see *Archivio Veneto*. vol. xiii. (Braghirolli); and *Gaz. des Beauxs Arts*, 3rd Period, vol. xv. (Yriarte).

2. This also occurs in the Castelfranco Madonna.

3. See Crowe and Cavalcaselle, *Life of Titian*, vol. i.

4. It is true that here certain definite forms remind us of Cima; the sprouting trunk behind the Baptist's foot, the sparse and elegant foliage of the tree to the left.

5. Probably S. Giovanni Chrysostomo himself, who after a life modelled upon that of Oedipus spent his old age in solitary devotion. The remarkable likeness of this figure in pose and type to the S. Jerome by Basaiti (dated 1505) in Mr. Benson's possession has led to the idea of that artist's collaboration here; but it would be easier to suppose that Bellini borrowed and transfigured a motive originated by his pupil than that Basaiti had a hand in so consummate an expression of Bellini's spirit as the S. Giovanni Chrysostomo.

6. See Crowe and Cavalcaselle, *Life of Titian*, vol. i. p. 174. The deduction made by them from the statement that it was finished "instante domino," namely, that Bellini did it at Ferrara "in the Duke's presence," is surely unnecessary; the phrase would more naturally imply that the picture had been long in hand and was finished "at the instance of the Duke." What difficulty the courtly patrons had in getting works out of Bellini to suit their taste, is evident from Bembo's letters to Isabella Gonzaga.

Afterword

by Hilton Kramer

Readers who nowadays know of Roger Fry mainly as a champion of modernism and as a member of the illustrious Bloomsbury group—it was Fry and his Bloomsbury friends who organized the first "Post-Impressionism" exhibition in London in 1910—often forget that this distinguished critic and connoisseur of the visual arts made his professional debut as a writer on Italian Renaissance painting. Before the discovery of Cézanne and Matisse that led to his becoming the leading writer on modernist painting in the English-speaking world of his day, Fry had established his critical credentials in the elite circle of international experts who, in the last years of the nineteenth century and the early years of the twentieth, presided over the systematic study of the Italian masters. His first book, the monograph on Giovanni Bellini published in 1899 and now reprinted for the first time since 1901, was the product of Fry's initial endeavors in this field of study.

It was, in fact, as a friend and sometime disciple of Bernard Berenson that Fry emerged in the 1890s as a recognized authority in this highly specialized and fiercely competitive world of connoisseurship. Berenson, though only one year senior to Fry, had already made himself a major figure in that world, and at the outset of his critical career Fry clearly owed a good deal to the aesthetic perspective that distinguished Berenson's studies of Italian painting. He appropriately acknowledged his "indebtedness" to Berenson's "generous encouragement and learned advice" in the preface to *Giovanni Bellini*. Yet Fry was too independent a

61

personality to remain anyone's disciple for very long, and Berenson was never to be famous for tolerating intellectual challenges to his own authority. Inevitably, there was a rupture in their relations, and it was accompanied by a good deal of rancor and recrimination on Berenson's part, especially in later years when Fry's influence on artistic thought greatly exceeded Berenson's.

Yet this later enmity should not be allowed to obscure the many qualities that these two critical eminences shared in a period that was crucial to their respective careers. Both, after all, joined in the post-Victorian recoil from the long shadow of Ruskin's influence on the study of art—an influence that was found by the generation of the 1890s to be incompatible with its own more narrowly focused concentration on the purely aesthetic attributes of a work of art. The implications of this shift in what were deemed to be the essential features of artistic experience were immense, for it entailed a radical rejection of much that Ruskin had placed at the center of his philosophy of art.

In common with other Victorian sages—Carlyle, Arnold, Newman—Ruskin took all of culture and society as his spiritual and intellectual province. What this meant, in his case, was that the experience of art was closely bound to a range of interests— nature, religion, politics, and the conduct of life—that made artistic judgments in one degree or another hostage to a variety of extra-artistic imperatives. This was precisely what the generation of Berenson and Fry sought to eliminate in favor of a more sharply focused attention to what were believed to be art's essential and irreducible qualities.

Still, Ruskin's was not an influence easily exorcised. He had brought a penetrating aesthetic sensibility to his art criticism, and that aspect of his work continued to cast a spell on the aestheticism of the 90s. He was also possessed of a missionary's zeal in elevating art to the status of a spiritual vocation. His own prose style, moreover, was a considerable artistic achievement in itself, and he had done something that no other writer on art in English had

ever succeeded in doing to the same extent—he had made the discussion of art a subject of compelling public interest. Thus, whatever there was in Ruskin's outlook on art that the Berenson/Fry generation wished to reject, they were nonetheless the beneficiaries of his success in placing art on the agenda of public debate.

Ruskin's epic-scale writings on the visual arts had enjoyed a huge readership that was to be denied to his successors, however. Yet if Berenson and Fry were obliged to write for a smaller, more elite public, it was precisely because the kind of aesthetic connoisseurship their writings fostered placed a severe limit on the number of readers who could be expected to respond to its demanding distinctions. It was not an interest of either critic to write about art, as Ruskin so often did, in the language of social prophecy and moral instruction. It was not what art might illuminate about other realms of experience that was of the greatest importance to them but, on the contrary, what art was in itself—what specific qualities in art set it apart from other realms of experience and accounted for the special appeal it exerted upon our imaginative and intellectual faculties.

Fry, of course, went much further than Berenson in the pursuit of these questions, which in the twentieth century could not be fully explored without taking account of the modernist art that appeared to challenge so many established measures of artistic accomplishment. This was something that Berenson famously refused to do, thus electing to become in every sphere beyond his own field of connoisseurship a kind of intellectual tourist of the period in which he lived most of his long life. Yet even in this matter it is worth recalling that Berenson, before turning his back on the art of the modern era, had paid sufficient attention to it to identify Cézanne and Matisse—Fry's later idols—as the most important of the modernist painters.

It is inevitable that we should look for clues to the later Fry—the author of *Vision and Design* (1920), *Transformations* (1926), and *Cézanne: A Study of His Development* (1927)—in the pages of *Gio-*

vanni Bellini. Some are discernible, to be sure, especially in passages like the following in which Fry's sensibility for pure painting manifested itself even before he was prompted to formulate a clear conception of its implications for criticism.

> The group of pictures we have just considered closes the second stage of Bellini's artistic career. During this period his aim was to obtain perfectly modulated transitions of tone within a precise contour. In the S. Giobbe altarpiece, which we may assign to about 1486 or '87, a new idea begins to be felt—the conception of enveloping the forms in atmosphere by means of a subtle variation of the quality of the limiting contours of the figures. This atmospheric envelopment of form is primarily a beauty of the surface quality of the picture, and not a matter of the scientific analysis of natural appearances; and though the richest effects of chiaroscuro cannot be obtained without it, it is quite distinct from the study of consistent arrangements of light and shade. Alvise Vivarini far surpassed Bellini in his research into the problems of light and shade; but lacking his sensitiveness both to beautiful tonality and to beautiful surface quality, he never acquired Bellini's atmosphere.

Fry's own tone here—judicious, authoritative, and impersonal—is closer to Berenson's than to the spirited polemical voice that we come to hear in a good deal of the later writing. Yet the matter-of-fact way in which Fry gives priority to "the surface quality of the picture" over "the scientific analysis of natural appearances" may legitimately be taken as an augury of the approach that would become more fully developed in all his subsequent criticism. In pondering the passage I have quoted, moreover, it is well to remember that in his study of the Italian masters Fry enjoyed one distinct advantage over Berenson: he was a painter himself. Not a major painter, to be sure, and at the time he was writing his monograph on Bellini, not very far advanced in his own artistic progress. But he nonetheless brought a painter's sensibility and experience to bear on the pictorial subjects he wrote about, and that gave to all his criticism, including the Bellini monograph, a salutary bias in favor of the purely aesthetic problems that were addressed in the art of whatever period he took under consideration.

Still, it won't do to search too assiduously for signs of the later

Fry in the pages of *Giovanni Bellini*. This book remains, in most of its essentials, part of the ongoing work of the 1890s in which the entrenched pieties, obscurities, and confusions that had accumulated around the paintings of the Renaissance masters were being systematically stripped away in the interest of a clearer, more objective understanding of their specific aesthetic characteristics. Upon the publication of this monograph there was every expectation that Fry would join the company of Berenson and others in devoting his talents to this formidable task of historical and aesthetic revisionism. A further study of the Bellini family was begun, and a book on Veronese was announced, but for a variety of compelling reasons—his wife's disabling illness, his own career as a painter, and the opportunities to work as a critic that were opened up for him by the publication of the Bellini monograph—Fry produced no more books on the Italian masters.

Instead he accepted an appointment as the art critic for the *Pilot,* a new weekly, moving a year later to the more influential *Athenaeum*. From 1903 onward he was also much involved, both as a contributor and an editor, on the then new *Burlington Magazine*. Thus was Fry launched on his career as the most important critic of his generation. His next book, *Vision and Design*, was a collection of essays drawn from these journals, and when he again took up the task of composing a monograph on a single artist, it was to write his *Cézanne*. The Italian masters remained an abiding interest, of course, and to a far greater extent than was reflected in the books he published, but Fry was never again to be exclusively identified as a specialist in Renaissance studies.

The Bellini monograph, in addition to being a fine study of a major artist, also affords an interesting perspective on Fry's overall development as a critic. For the early critics of modernist art in the twentieth century may be usefully divided into two groups. In the first and more numerous group are to be found all those writers who greeted virtually every manifestation of the modernist spirit in painting as a decisive break with the great traditions

65

of Western art. There was a second, smaller group, however, that saw the situation very differently. These were the critics who welcomed the emergence of modernist painting with a keen sense of what it owed to the traditions that it often appeared to repudiate. In the English-speaking world of his day, Fry was pre-eminent in this latter group. To understand what modernism owed to tradition, it was necessary, alas, to have a deep comprehension of what tradition consisted of in purely aesthetic terms. This was indeed the key to Fry's distinction as a critic of both traditional and modernist art. Reading *Giovanni Bellini* nearly a century after its original publication, it is therefore important to recall Fry's own observations on the resistance that this critical intelligence met with when he first turned his attention to modernist painting. In his "Retrospect" for *Vision and Design* he wrote:

I found that the cultured public which had welcomed my expositions of the works of the Italian Renaissance now regarded me as either incredibly flippant or, for the more charitable explanation was usually adopted, slightly insane. In fact, I found among the cultured who had hitherto been my most eager listeners the most inveterate and exasperated enemies of the new movement. The accusation of anarchism was constantly made. From an aesthetic point of view this was, of course, the exact opposite of the truth.... In any case the cultured public was determined to look upon Cézanne as an incompetent bungler, and upon the whole movement as madly revolutionary. Nothing I could say would induce people to look calmly enough at these pictures to see how closely they followed tradition, or how great a familiarity with the Italian primitives was displayed in their work.

We are thus reminded that Fry's *Giovanni Bellini* marked a stage in his development that he shared with some of the greatest artists of his own era.

Plates

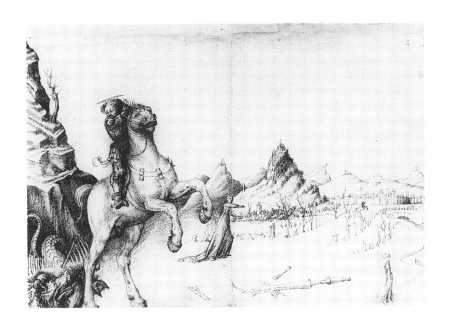

JACOPO BELLINI, *St. George and the Dragon*: Louvre.

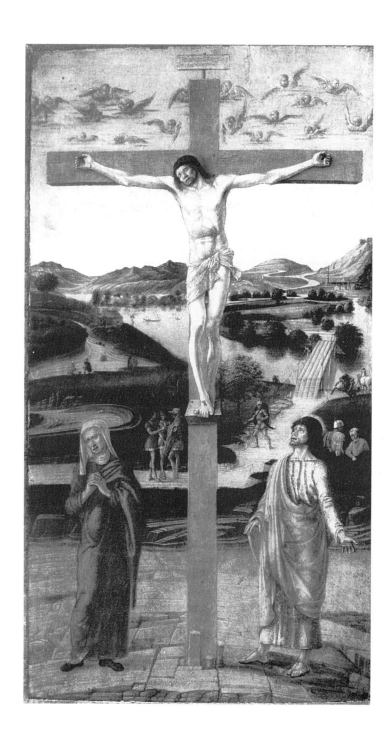

The Crucifixion: Correr Museum, Venice.

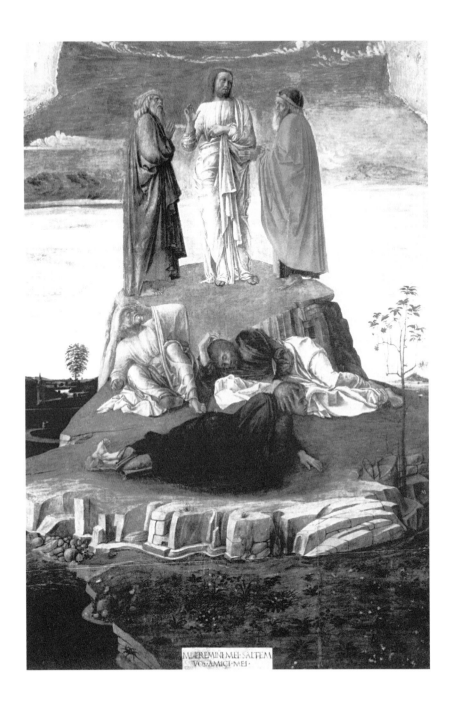

The Transfiguration: Correr Museum, Venice.

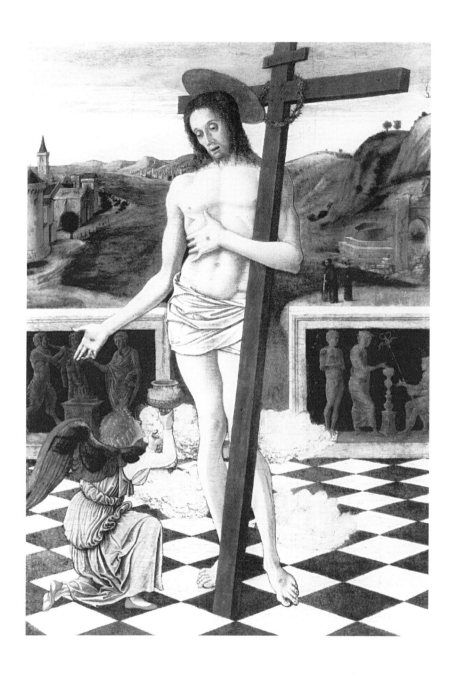

The Blood of the Redeemer: National Gallery, London.

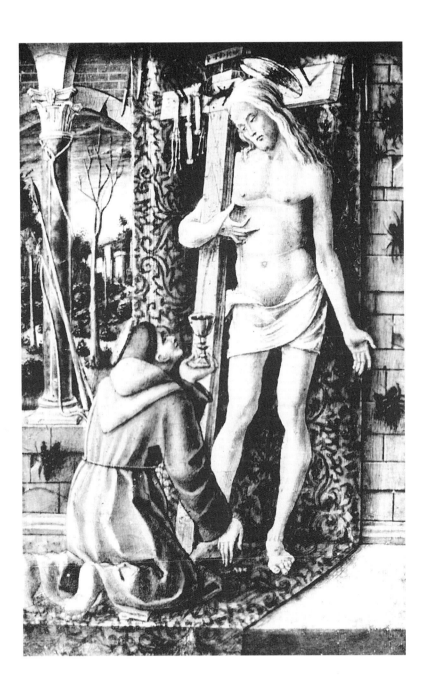

CRIVELLI, *The Blood of the Redeemer*:
Poldi Pezzoli Collection, Milan.

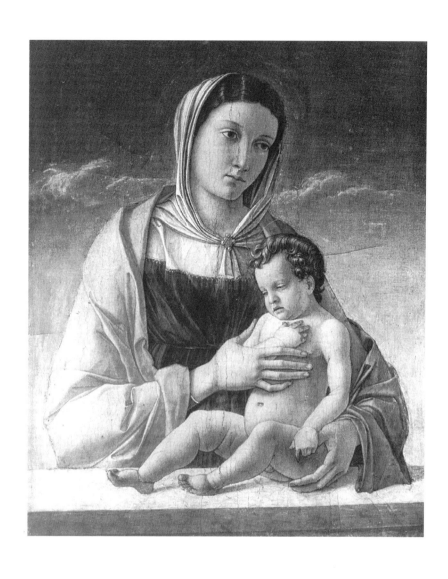

Madonna and Child: formerly Frizzoni Collection, Milan; now Correr Museum, Venice.

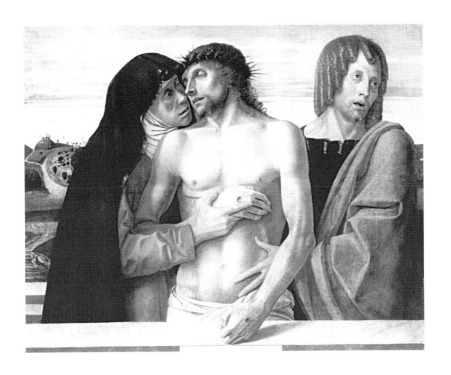

Pietà: Brera, Milan.

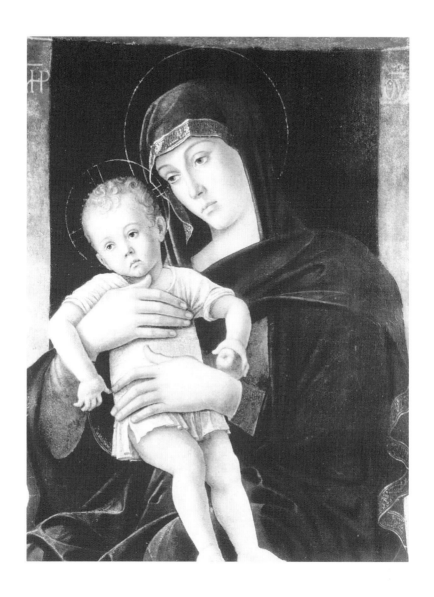

Madonna and Child: Brera, Milan.

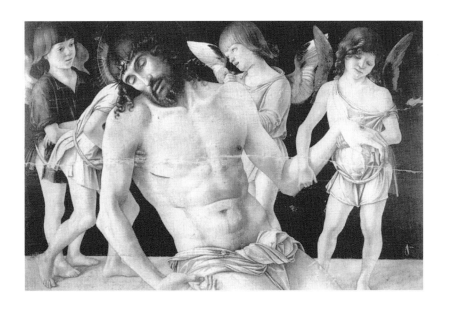

Pietà: Communal Gallery, Rimini.

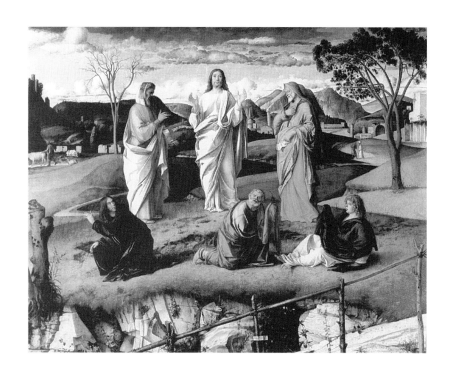

The Transfiguration: Museum, Naples.

The Coronation of the Virgin: S. Domenico, Pesaro.

The Conversion of St. Paul: Predella of Altarpiece, Pesaro.

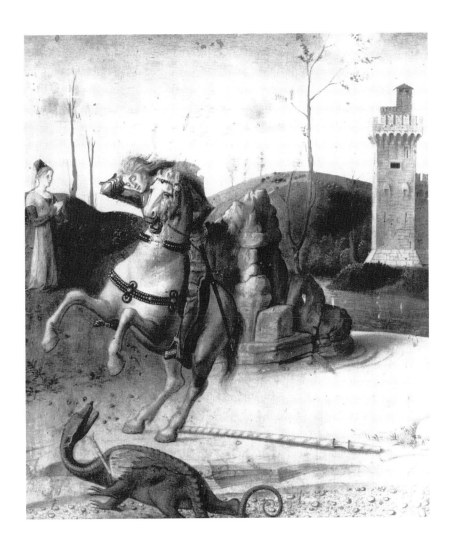

St. George and the Dragon: Predella of Altarpiece, Pesaro.

Madonna and Saints; Altarpiece: SS. Giovanni e Paolo, Venice.
(From a copy.)

Madonna and Saints; Altarpiece: Frari, Venice.

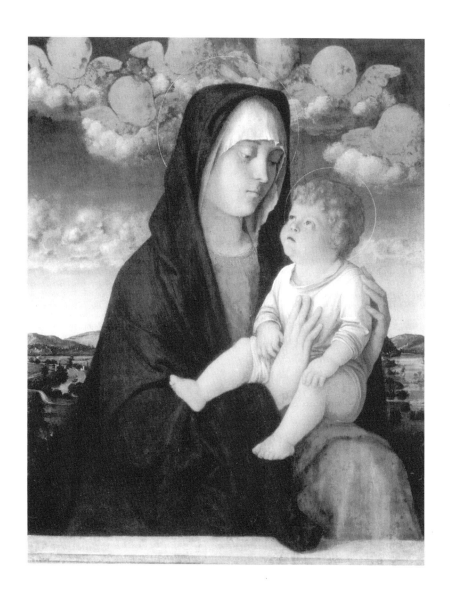

Madonna and Child: Academy, Venice.

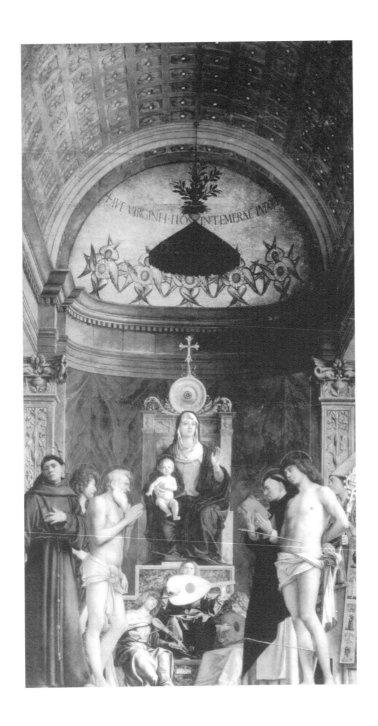

Madonna and Saints; Altarpiece of S. Giobbe: Academy, Venice.

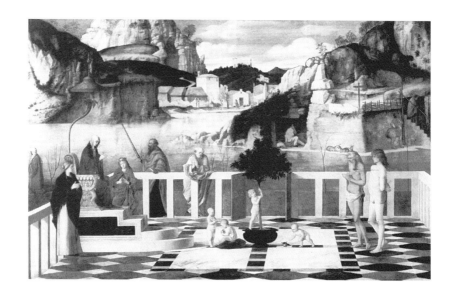

Sacred Allegory: Uffizi, Florence.

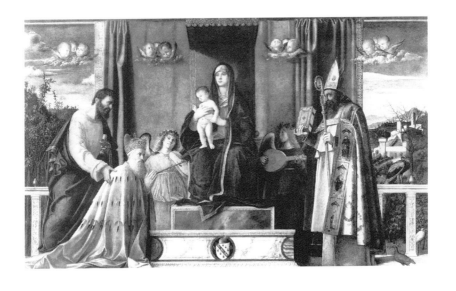

Madonna with the Doge Barbarigo;
Altarpiece: S. Pietro Martire, Murano.

Ardour and Luxury: Academy, Venice.

Prudence: Academy, Venice.

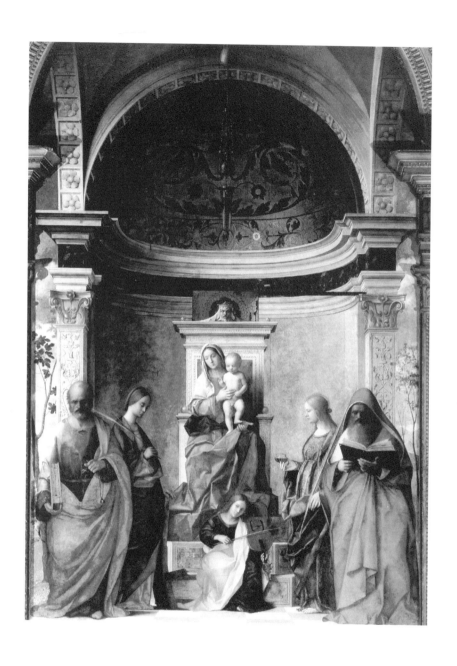

Madonna and Saints; Altarpiece: S. Zaccaria, Venice.

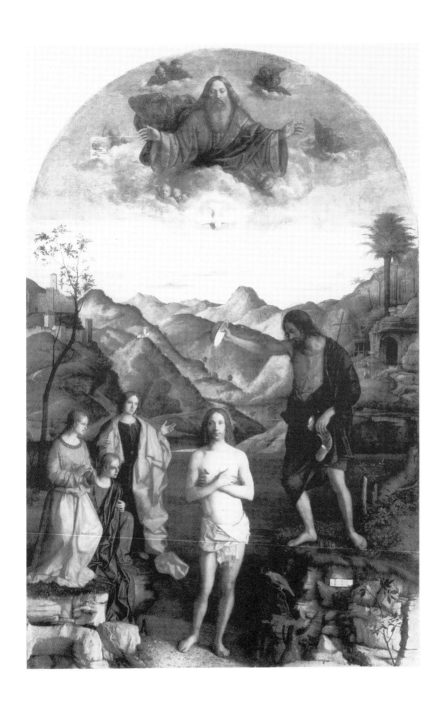

Baptism of Christ: S. Corona, Vicenza.

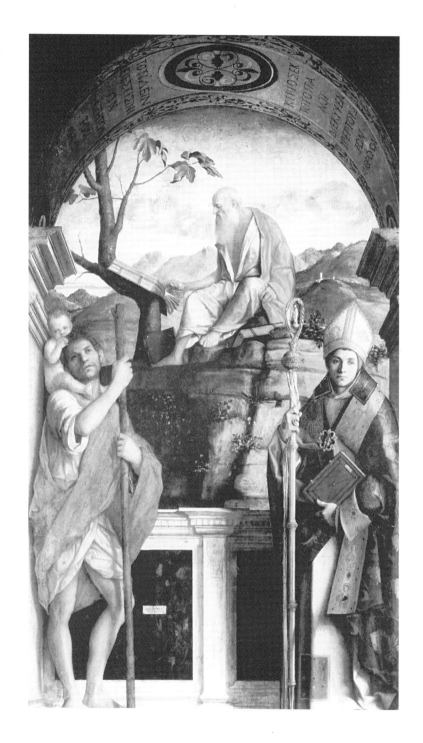

Altarpiece: S. Giovanni Crisostomo, Venice.